Journey Into Artistic Knowledge Of Sufism

M. Abdul Hakeem

PARTRIDGE

Copyright © 2023 by M.Abdul Hakeem.

Library of Congress Control Number:	2022923269
ISBN: Softcover	978-1-5437-7250-0
eBook	978-1-5437-7251-7

All rights reserved. No part of this book may be used or reproduced by any means, graphic, electronic, or mechanical, including photocopying, recording, taping or by any information storage retrieval system without the written permission of the author except in the case of brief quotations embodied in critical articles and reviews.

Because of the dynamic nature of the Internet, any web addresses or links contained in this book may have changed since publication and may no longer be valid. The views expressed in this work are solely those of the author and do not necessarily reflect the views of the publisher, and the publisher hereby disclaims any responsibility for them.

Print information available on the last page.

To order additional copies of this book, contact
Toll Free +65 3165 7531 (Singapore)
Toll Free +60 3 3099 4412 (Malaysia)
orders.singapore@partridgepublishing.com

www.partridgepublishing.com/singapore

In Memory of
Sheikh Muzaffer Ozak Al-Jerrahi

He is a Waliullah, or intimate friend of Allah, as saints are
referred to in Islamic Tradition. For twenty years Sheikh
Muzaffer Ozak Al-Jerrahi was the Sheikh of the Halveti
Jerrahi Order of Dervishes. A prolific author in The
Turkish Lanauage, Sheikh Muzaffer was well-known
for his sage advice, spiritual counseling and his mastery
dreams interpretations.

 He was educated by a succession of wise and learned
teachers who instructed him in all branches of the
Islamic Tradition. He became Muezzin and later took

the Office of Imam in many of the mosques in Istanbul.

He later retired from the Office of Imam and preached a sermon of Friday at a mosque near the famous Istanbul book market, where he owned a shop specializing in antiques and religious books.

Extensive travels took him not only on Pilgrimage to Mecca eleven times and throughout the Middle East, but also to the Balkan Countries, Western Europe and The United States of America where his deep love for American People was expressed in his founding of numerous branches of The Halveti-Jerrahi Order.

TABLE OF CONTENTS

ACKNOWLEDGEMENTS. v

INTRODUCTION. 1

Chapter

 I. THE MEANING AND ORIGINALITY OF MYSTICISM. 3

 The Meaning of Sufism 6

 The Objectivity of the Sufi 17

 II. THE STATIONS OF WISDOM IN SUFISM. 19

 The Station of Love 20

 The Station of Knowledge. 23

 The Station of Will 24

 III. FINE ARTS AND SUFISM. 25

 The Perennial Values in Sacred Art. 33

 How Does Art Serve the Spiritual Life 50

 The Way Art Functions in a Person
 with Spirituality 54

 IV. SUFISM AND ART EDUCATION. 56

 The Process of Creativity in Art Education. . . 65

 The Sufi Method in Art Education. 71

CONCLUSION. 92

APPENDIX. 99

BIBLIOGRAPHY. 107

INTRODUCTION

For numerous reasons, some positive and many negative, there is much enthusiastic interest in Sufism in the western world, while in the Arab world the interest is even greater. The fall apart of the value system of the modern world; a sense of insecurity concerning the future; an incomprehension prevalent in the western world of the message of religions whose inner teachings have become increasingly inaccessible; the desire for a vision of the spiritual world within a deviant and perverted environment.

This type of environment has caused people to quest for the inner spiritual teachings of oriental religions. I am one of these individuals who is searching for dwindling traces of spirituality that still exist in the world that will take in the realm of my inner self, casting away my present life or else facing a life of anxiety, pseudoreligion, superficial knowledge, and the all-pervasive illusory pleasure and commitments that characterize the civilization of the dark age.

My immediate enthusiasm in Sufism has expanded my consciousness, the annihilation of false ego, to create a tolerance towards different religions and to see them as one. The forces of Sufism have made me conceive. When an artist like myself conceives, he produces only that which his inner self recognizes as having been conceived,

and it has broadened my perspective and the appreciation of many art forms and enabled me to perceive more fully the spirituality of many art forms.

The purpose of this report is to explore and present to the reader a basic understanding of Sufi ideas and thoughts and some aspects of Sufism's universal and humanistic culture. Most significant of all is the value of Sufism in art education, and how it can be beneficial to the student and to the teacher.

CHAPTER I

THE MEANING AND ORIGINALITY OF MYSTICISM

In recent years many books have been published on the subject of Sufism and spiritual life in Islam. These two subjects have touched upon different facets, for the phenomenon called Sufism is so broad and its appearance so protean that nobody can venture to describe it fully; like the blind men in Rumi's famous story[1] who, when they were made to touch an elephant, each described it according to the part of the body his hands had touched: to one the elephant appeared like a throne, to another like a fan, or like a water pipe, or like a pillar. But none was able to imagine what the whole animal would look like.

In this case, Sufism is the general name for Islamic Mysticism. To approach its inner meaning we must ask ourselves what is the meaning of mysticism. Mysticism is something mysterious, not to be reached by ordinary means or by intellectual effort, as is understood from the root words mystic and mystery, the Greek _myein_, "to close the eyes."[2] Annemarie Schimmel's definition of mysticism is

[1] Thirteenth century Persian Sufi poet and scholar.

[2] Annemarie Schimmel, _Mystical Dimensions of Islam_ (Chapel Hill: The University of North Carolina Press, 1975), p. 3.

not complete in its utmost form. Such a definition is only her point of view without going into it deeper.

Mysticism has no conotations with religion, belief, principle, or dogma. A mystic is born; to be a mystic means to have a certain temperament, and a certain outlook on life. Mysticism is the basis of all knowledge: science, art, philosophy, religion, and literature. Most people define a mystic as a dreamer, an unpractical individual who has no knowledge of worldly affairs. However, a mystic is a person who has a complete sense of balance between the spiritual world and the material world.[1]

People have so many misconceptions of what a mystic is. Mystics have been called fortune-tellers, clairvoyants, and visionaries. I do not mean that a mystic does not possess all these qualities, but these qualities do not create a true mystic. A real mystic should be an artist, a scientist, or an influential statesman. A mystic removes the barriers that stand between himself and others by trying to look at life not only from his own point of view, but also from the point of view of another. Most disputes and disagreements arise from individuals' misunderstanding of each other, and most people misunderstand each other because they have their fixed point of view and are not willing to move away from it. The more dense an individual is, the

[1] Inayat Khan. *The Sufi Message of Hazrat Inayat Khan*, *Volume X* (London: Barrie and Jenkins, 1973), p. 13.

the more he is fixed in his own point of view. Therefore it is easy to change the mind of an intelligent person, but it is most difficult to alter the mind of a fool once it is fixed.

Many people fear to look at things from the point of view of someone else; they lose their own point of view. But I would rather lose my point of view if it was a wrong one. Why must one stick to one's point of view simply because it is one's own opinion? And why should it be one's own point of view and not all points of view, the point of view of one and the same spirit? For, just as two eyes are needed to make sight complete and two ears are necessary to make hearing complete, so it is the understanding of two points of view, opposite points of view, which gives a fuller insight into life.

A mystic calls this unlearning because, when the mind has fixed ideas, this learning is not freeing the soul; it is limiting the soul. By this I do not mean that learning has no place in life, but only that learning is not all that is needed in the spiritual path. Learning is just like making knots of ideas, and the thread is not smooth as long as the knots are there. They must be unraveled, and when the thread is smooth one can treat it in any way one likes. A mind with knots in it cannot have a smooth circulation of truth and ideas. When this happens the mind becomes blocked and there will be no room for creativity.

A mystic, therefore, must see all points of view in order to clarify his knowledge.

The Meaning of Sufism

Now I arrive at the most significant part of this chapter, the meaning of Sufism. The majority of books on the subject define Sufism as mainly an interiorization of Islam, a personal experience of the central mystery of Islam, "to declare that God is one." Sufism has always remained inside the fold of Islam, and is the mystical attitude that is not limited by adherence to any of the legal or theological schools.[1]

The most common definition of Sufism can be explained by an eleventh century Persian Sufi by the name of Ali ibn Uthman Hujwiri, who summed up the discussion: some assert that the Sufi is so called because he wears a woolen garment, others that he is so called because he is in the first rank, others that it is because the sufies claim to belong to the people who gathered around the Prophet Muhammad's mosque. Others declare that the name Sufism is derived from _safa_ (purity).[2]

But the meaning of Sufism is more than the "wearing of a woolen garment" and "an interiorization of Islam."

[1] Schimmel, _Mystical Dimensions of Islam_, p. 17.
[2] Ibid., p. 14.

There are three principles of philosophical thought in the east: Sufism, Vedantism, and Buddhism. The Sufi school of thought is composed of the prophets Abraham, Moses, David, Jonah, Zarathushtra, Christ, Muhammad; these and other prophets came from Syria, the Arabian Peninsula, Persia, and Egypt.[1]

The Sufi school of Arabia was largely metaphysical; the Sufi school of Persia developed more the literary aspect; and the Sufi school of India developed the meditative faculty; the truth of the matter is that these Sufi schools have remained the same, as the central theme of Sufism. Several Sufi schools exist even today, and it would not be an exaggeration to say that there are millions of souls, the followers of various religions, who have benefited from the wisdom of these schools.

Sufism is not a religion of itself, nor a cult with a distinct or definite doctrine. No better explanation of Sufism can be given than by saying that an individual who has knowledge of both outer and inner life is a sufi. Another meaning for Sufism is the Arabic word _saf_, which means _pure_. All the tragedy in life comes from the absence of purity, and as to be pure really means to be natural, the absence of purity means to be far from being natural.

[1] Inayat Khan, _The Sufi Message of Hazrat Inayat Khan_, Volume VIII (London: Barrie and Jenkins, 1973), p. 18.

Sufism, therefore, is the process of making one's life
natural. One may call this process a religion, a philo-
sophy, a science, or mysticism, whichever one wishes. The
teachers of religious philosophy who have come to this
world at different times have brought this process of
purification in the form of a religion. It is the same
ancient process that the wise men of all ages have
bestowed.

One may think that by spirituality one must learn
something which one did not know before, that one must
become extraordinarily good and acquire some unusual
powers. None of these things does Sufism promise, although
on the path of Sufism nothing is too wonderful for one. By
the process of Sufism, one realizes human nature, and by
studying human nature, one can realize the nature of life
in general. All failures, disappointments, and sorrows are
caused by the deficiency of realization; all success,
happiness, and peace are acquired by the realization of
one's own nature. In short, Sufism means to know one's
true self, to know the purpose of one's life, and to know
how to accomplish that purpose. The disappointment of not
having a successful life is the result of not realizing the
fact that man is born to do what he longs to do, and that
success is natural while failure is unnatural. When man
possesses self-realization, the whole world is his; without
self-realization, he does not know what he is, where he is,

BIOGRAPHY

American born of Caribbean grandparents.
Educated at Pratt Institute and Teachers College,
Columbia University. I have taught for 35 years
in New York, Colorado and Turkey and have studied
Sufism for 40 years, while experiencing several
sufi orders. I have also traveled extensively to
Europe, Asia, North Africa and North and South
America.

nor why he is here on earth; then he is less useful to himself and to others.

Sufism can serve the function of reminding mankind of who he really is, which means that man is awakened from this dream which he calls his ordinary life and that his soul is freed from the confinees of that illusory prison of the ego, which has its objective counterpart in what is called "the world" in religious parlance. By appealing to the true nature of man, Sufism fulfills the real needs of his nature, not what he feels to be his needs in terms of the outer world into which it has plunged its roots. Man seeks his psychic and spiritual needs outwardly precisely because he does not know who he is. Sufism reminds man to seek all that he needs inwardly within himself, to tear his roots from the outer world and plunge them in divine nature, which resides at the center of his heart. Sufism removes man from his lowly state of soul in order to reinstate him in his primordial perfection of attitude wherein he finds within himself all that he had sought outwardly, for, being united with God, he is separate from nothing.[1]

Sufism speaks essentially of three elements--the nature of God, the nature of man, and the spiritual virtues --which alone make possible the realization of God and which alone can prepare man to become worthy of the exalted

[1] Seyyed H. Nasr, *Sufi Essays* (New York: Schocken Books, 1972), p. 34.

station of Ahsan Taqwim,[1] of becoming the total theophany of God's names and qualities.

Very often, Sufism is taken as a sign of pacifism. Sufism does not teach such a concept. Sufism does not mean goodness, kindness, or piety; Sufism means wisdom. All things in life are materials for wisdom to work with, and wisdom cannot be restricted to any principles. Among the Sufis, there have been great souls who were kings, saints, workmen, scholars, beggars, commanders, generals, businessmen, statesmen, or artists; and in all ages the Sufis have practiced Sufism in all walks of life. Thus, no one can point out a particular belief or tenet and say it is a Sufi doctrine.

In music, there are two distinctive features: sound and notes. Notes indicate the degree of sound, but sound can be all notes. The same is true of Sufism. Sufism is made up of all beliefs. There is no action which the Sufi calls right or wrong, for every action can be classified as wrong. Right or wrong is dependent upon the attitude and the situation, not upon the action.[2] This type of behavior seems to be more natural and it allows more room for tolerance towards others and makes man ready to forgive them,

[1] God created man as the most complete and perfect theophany.

[2] Inayat Khan, The Sufi Message of Hazrat Inayat Khan, Volume VI (London: Barrie and Jenkins, 1973), p. 254.

since he is unwilling to form an opinion about the action
of another person. This attitude keeps the Sufi from
saying that peace is good or war is good. The Sufi will
prefer to say that war is good at a time of war and that
peace is good at a time of peace.

All through the ages, different religions have been
given to mankind for his spiritual development with the sole
concept of unity. Many people who belong to a church
accept its dogmas, claim a certain name for their religion,
and consider all other religions of God as separate. By
doing so, they lose the very essence of wisdom, for whose
development that religion was given. This error has existed
from the very beginning of time. Instead of touching the
true spirit, people have lost the reality of seeking a
false objective. Religious differences have caused wars and
disasters for the human race, because the spirit of unity
has not been recognized, while undue regard has been paid
to uniformity.[1] At the present time, religion is at its
lowest peak, and only the uniformity remains. Divisions of
classes and discords between people are springing up. The
effect of this has been to keep mankind far away from
consciousness of himself and of his creator. All of this,
humanity is laboring under a great unrest; and yet, man
thinks he is progressing, while at the same time it is only
progress towards a greater unrest.

[1] Ibid., p. 253.

There will never be true progress when nations and peoples are divided; for when the races are divided there is little room for tolerance and understanding towards each other. The same spirit of destruction is at work at all times, and even families come to be separated. Unity seems to be rooted out from the hearts of men. Examples are not necessary: one just has to look around and one can see the condition of life in the world. When we seek a reason for this we find a right principle wrongly worked out. Uniformity is not a fault, indeed it is a great virtue; there is nothing wrong, for instance, in a uniform desire to help, to give service in time of need. But when God-ideal is removed, the body remains without a soul. However alive and prosperous the world may seem, life belongs only to the living, and when the living being is forgotten, it is like a light under a bushel. Man becomes so absorbed in the pursuit of money that he becomes intoxicated and indifferent to the harmony and happiness of others, and even to the harmony of his own being; and then he causes destruction. We have only to think of the wars humanity has gone through, and of this latest horror, to see the truth. It all proves that progress is taking the wrong direction, and that unity is lacking. The scriptures were given to the Jews, the Christians, the Muslims, Parsis, Hindus, Buddhists, all, as their central truth, the message of unity, but man has been so interested and absorbed in the poetry of these scriptures

that he has forgotten their inner voice. If mankind would
only recognize the inner voice of religion, mankind would
see that the different scriptures contain words spoken by
one and the same voice.

The work of the Sufi is to marry all of the world
religions in universal brotherhood. Among Christians, he is
a Christian; among Jews, he is a Jew; among Muslims, he is a
Muslim; among Hindus, he is a Hindu; for he is one with all,
and thus all are with him. The Sufi permits everyone to
join in his brotherhood, and in the same way he allows
himself to join others. He will never question the creed or
nationality of others, nor the religious techniques or
principles one adheres to.[1] The Sufi adheres to no peculiar
principle: a principle may be beneficial to one and harmful
to another. For example, if we ask a soldier to be merciful
during combat and he is defeated, this displays that
everyone has his own principle for every situation. The
Sufi, instead of becoming centered on his likes and dislikes
and limiting himself to certain faith or principles, focuses
his opinion on that of another, and thus sees the reasons
why he believes and why he does not. He also understands
why that which is called good by some people may be called
bad by others, and thus by keeping his point of view under
control, he arrives at the true height of wisdom.

The Sufi is a Christian in the areas of charity,

[1]Ibid., p. 257.

brotherhood, and healing of his own soul as well as the soul of another. He is no bigot in his adherence to a particular church or in forsaking other masters and their followers who came before and after Christ. It is the life of the Sufi to observe the real picture of the life and teachings of Christ, especially in the sharing of home and food with his fellow beings. Even up to the present day, the Sufi continue their ways of purity. The Sufi is a Catholic, because he produces a picture of ideas of devotion in his sould, and he is a Protestant in giving up the ceremonials of religion.

The Sufi is a Brahmin, for the word Brahmin means "the knower of Brahmin, of God, the only being."[1] His religion lies in believing in no other existence save that of God, which the Brahmin call advaita.[2] The Sufi considers the teaching of Avatars[3] to be true manifestations of the divine wisdom, and a perfect insight into the knowledge of the Vendanta.[4] The Sufi appreciates the Jain[5] conception of harmlessness, and he considers that kindness is the true

[1] Brahmin is the supreme and eternal essence or spirit of the universe.

[2] Advaita is to believe in the existence of God.

[3] Avatars is when God comes down in bodily form to earth; incarnation of a god.

[4] Vedanta is a system of Hindu monistic or pantheistic philosophy based on the Vedas.

[5] Jain is to believe in Jainism--a Hindu religion resembling Buddhism, founded in the 6th century B.C.; it emphasizes asceticism and reverence for all things.

path of purity and perfection.

The Sufi is a Buddhist, because he experiences the same as the Buddhist in stepping forward on his spiritual journey. The teachings of the Sufi are very similar to the Buddhist teachings; in fact, it is the Sufi who brings together the believers and the unbelievers, in the God-ideal and in the knowledge of unity.

The Sufi is a Muslim, not because most Muslims happen to be Sufis, nor because of his use of Muslim phraseology, but because in reality he proves what a true Muslim ought to be. The majority of Muslims possess a great deal of devotion. No matter how great a sinner or how cruel a man may be, the name of Allah (God) or Muhammad at once reduces him to tears. The practice Sufism first develops is the qualities of the heart, which are often overlooked by many other mystics. The development of the qualities of the heart will purify and illuminate the soul. The Sufis read the Holy Quran from every experience in life, and see and recognize Muhammad's face in each atom of the manifestation.

The Sufi is like a Zoroastrian. He looks at the sun and bows before the air, fire, water, and earth, the immanence of God's manifestation, taking the sun and moon as the sign of God. The Sufi interprets fire as a symbol of wisdom and celestial spheres.

Finally, the Sufi is an Israelite, because he studies and masters the different names of God. The miraculous

powers of evolution of an illuminated soul in Moses can be found in the lives of the Sufis. In fact, the Sufi is the master of Hebrew mysticism; the divine voice heard by Moses on Mount Sinai in the past is audible to many a Sufi today. No matter what the sect, cult, or creed may be called, as long as the soul is striving toward that object, to a Sufi all are Sufis. The attitude of the Sufi toward all different religions is one of reverence. His religion is the service of humanity, and his only object of attainment is the realization of truth.

The Objective of the Sufi

The Sufi's aim in life is no different from any other religion, not to abuse any society. He does not see weaknesses or faults in these religions, but he sees good in all of them. The Sufi's aim is the aim of the entire world: knowledge; but at the same time he wants to harmonize and to unite with others. Thus, his aim is to see no duality, but unity, and this is, in fact, the objective of all religions; the only difference is that this objective has been declared more or less plainly at different stages in the world's evolution. The Sufi seeks to reach the experience of different religious philosophies, so that he can rise above the norm of religion and deal with the awakening of his real self. The Sufi wants to spread the knowledge of unity, the religion of love and wisdom, so

that the bias of faiths and beliefs may fall away, the human heart may overflow with love, and all hatred caused by distinctions and differences may be rooted out.

The task of the Sufi is to remove the covers of false ego. When the ego is covered with so many different vibrations, he cannot see his true self. The Sufi, by his meditation, takes off the physical body and observes what he can see without it. Then he rids himself of the astral plane of false ego. When this happens, his consciousness stands before him and he has achieved self-realization. This self-realization is like a curtain before which one stands with a small lantern. The reflection of the lantern is cast upon the curtain and it detaches or it limits a certain part of the curtain which receives the impressions.

The purpose of self-realization is to let one's spirit rise above oneself. It presupposes at the very least some remote awareness of the existence of the heart, which is the point where the human self ends and the transcendent self begins. If the clouds in the night of the soul are so thick as to prevent the moon of the heart from showing the slightest sign of its presence, there can be no self-realization.

CHAPTER II

THE STATIONS OF WISDOM IN SUFISM

In all ages of man's existence, we find the tradition of a recondite wisdom, which could disclose the basic understanding of things around man. This wisdom was generally known as Sufism. Wisdom is the fundamental principle on which all things rest, in the inherent divine nature of man and of self-knowledge. When man learns about such subjects as philosophy, science, art, history, and literature, he is engaging in the absolute wisdom of humanity as a whole hierarchy of celestial spheres. From time to time, divine wisdom would incarnate and would give to the world more of an outlook toward each other and the individual might be led to enter the real path of wisdom which would enable him to realize his own divine, supernatural powers.

Now although mankind as a whole has accomplished this return process of wisdom only through cycle after cycle of effort and renewed effort, extending over millions of years, in which, as we clearly see--even in the short period of a few thousand years of which we have any records--nations have their birth, maturity, and death, yet there is always the possibility for the individual to step out in advance, achieving real wisdom that would liberate him from the

"fate sphere" of this lower world of spiritual life. Indeed, it is only by such actual wisdom that he can be liberated.

Until civilized man has achieved that wisdom, he is helpless in commanding the cosmic law. His command of the cosmic law, which he utilizes to produce phenomena absolutely incomprehensible to the savage, would be as useless to himself as to his fellow man. "Civilized" man, with all of his modern science, has no real wisdom. He does not know enough to save his fellows from the scourge of disease. His wisdom of physical things is a mere surface wisdom, derived solely from his own physical senses, not from the spiritual senses, and is limited thereby. True, he is beginning to have some apprehension of the vast spiritual power of the mind over physical matter,[1] and certainly a science of psychological wisdom, but here again he is only touching the fringe of spiritual wisdom.

The Wisdom of Love

Wisdom is comprised of three stations: love, knowledge, and will. On the station of love is the effective life of the soul. We can distinguish an active mode and a passive. The passive mode is made up of contemplative contentment and of patience; it is the calm of that which is

[1] William Kingsland, *The Gnosis and Christianity* (Wheaton, Ill.: The Theosophical Publishing House, 1975), p. 95.

at rest in itself, in its own virtue; it is open-hearted relaxation, harmony; it is repose in pure being, equilibrium of all possibilities. This type of attitude loosens the knots in the soul of an individual, it removes agitation, dissipation, and the strain which is the static counterpart of agitation. The quality of calm comes from divine peace within oneself, which is made of bliss, of infinite beauty. Beauty always has at its root an aspect of calm,[1] of existential repose, of equilibrium of possibilities; that is, it has an aspect of limitlessness and of happiness.

But there is, beside this repose in our initial equilibrium or in our existential perfection, an inverse positive tendency, a going out of oneself in the active mode; this is fervor, confident and charitable faith; it is the fusing of the heart in the heart of spirituality; it is opening to mercy, essential life, infinite love. Mankind in his fallen condition is closed to the mercy which seeks to save him; this is "hardness of the heart," indifference toward himself and his neighbor. His egoism, greed, mortal triviality, such conditions are as it were the inverse counterpart of hardness of the heart; the fragmenting of the soul among sterile facts, in their insignificant and empty multiplicity, their dessicating, drab monotony; the chop and change of ordinary life, where ugliness and humdrum

[1] Frithjof Schuon, *Stations of Wisdom*, trans. G. E. H. Palmer (London: John Murray, 1961), p. 150.

pose a reality.

The essence of the soul who experiences love is in a state of blessedness. But if the love experience is not present, the soul is hard like a stone and pulverized as sand; it lives in the dead rings of things and not in the essence which is life and blessedness; it is at once both hardness and dissolution. We make ourselves strangers to ourselves and to others. We are driven into destitution and ugliness. The annihilation of the ego is the love of one's self; this is fervor, intense unification of the movements of the soul on an upward flight of faith in the divine mercy: her is the warm, soft quality of spring, or that of fire melting ice and restoring life to frozen limbs.

Charitable acceptance of the neighbor and encountering the brotherhood of man are necessary manifestations of this alchemical liquefaction of the heart. They are as it were the criteria for that tendency--or state--of the intelligence and the will which we can call "love of God." They are so firstly because egoism, which is a form of petrifaction, is compensated for and overcome by every going outside of ourselves, and secondly because the image of God appears in our neighbor; in other words, we need them to love God not only to lose ourselves, but also to recognize God in others. This spiritual quality is like a fire, which burns and melts the soul, which gives life to the body from within; it is like love too, or wine, which bring intoxi-

cation and seem to transport a man back to the essence; or like a red rose, whose color burns and whose perfume is overpowering. This is the way of mystical love; joy and bliss and sobriety--or hope and resignation--meet in peace.

The Wisdom of Knowledge

The wisdom of knowledge goes beyond the realm of the ego as such. It comprises and separate mode and a unitary mode, as the very nature of gnosis requires; or, as could also be said, an objective mode and a subjective mode, in the deepest sense of these terms. Knowledge, in fact, operates either by discrimination or by identification. Either it perceives or it conceives. Discriminative knowledge separates the unreal from the real. It is like the night when the moon is shining: we recognize the moon at night, and though the light of the moon is indeed that of the sun, we are not in broad daylight. Seen from the perspective of metaphysical discrimination, the subject is individuation, illusion, limitation; the object--that is to say that which is outside of us--is the principle wisdom of self-knowledge.

The wisdom of knowledge belongs exclusively to esotericism; it includes doctrinal understaning on the one hand and unitive knowledge on the other. If the spirit of an individual knows reality, he has the unitive knowledge of becoming conscious of himself and of things around him. The

mind must, in addition, be conscious of the nothingness of the false ego and of the world; it must surmount the congenital confusion which contributes to the unreal; it must empty the ego, and empty itself of the ego. Reality can be known only in the void.

The Wisdom of Will

The wisdom of will is to deny and affirm: if it is to deny by reason of the falsity of its habitual objects, which are impermanent, it must on the other hand affirm by reason of its positive character, which is freedom of choice. Since spiritual action must assert itself with force against the lures of the universe or of the soul, which seek to engross and corrupt the very essence of will in man, such action involves the combative virtues: decision, vigilance, perseverance. It is in turn conditioned by man, not in its unique actuality but in its relationship with duration, whic which exacts repetition, rhythm, the transmutation of time into instantaneity. Spiritual action is, on its own plane, a participation in omnipotence, in spiritual and material liberty, in the pure and eternal act.

All these stations concern on the one hand God, the metacosm, and on the other the soul, the microcosm; but therein is also the key to the alchemical comprehension of the world, the macrocosm.

CHAPTER III

FINE ARTS AND SUFISM

To understand the essence of the sacredness of fine arts in Sufism, we must understand the meaning of sacred and the definition of art, which today has become divorced from human life. But first, to understand the sacred, we must comprehend the traditional view of reality. By tradition, we do not mean customs or habits, but rather all that comes from heaven and has a spiritual and mystical foundation. Tradition would correspond to the term *din* in Persian and Arabic in its most universal sense.

In a traditional view of the universe, reality is multi-structured and possesses several degrees of existence. It issues forth from God, and it consists of many levels which can be summarized as the angelic, psychic, and physical worlds. It is to the metacosmic source, then to being, and finally to the three principle worlds mentioned above that the term "the five spiritual presences" refers. Man lives in the awareness of this reality even if its metaphysical and cosmological exposition is beyond the ken of the spiritual and intellectual elite.

The sacred marks an eruption of the higher worlds in the psychic and material planes of existence. The sacred

comes directly from the spiritual world, which stands directly above the metaphysical world and must not be confused with the one being, Ruh[1] and the other, Nafs,[2] which in Islamic parlance are sacred, as is all that serves as a vehicle for the return of man to the spiritual world. But Nafs is inseparable from Ruh because essentially only that which comes from the spiritual world can act as the vehicle to return to that world. The sacred, then, marks the "miraculous" presence of the spiritual in the material, of heaven on earth, and it is an echo from heaven to remind man of his heavenly origin.

Traditional and sacred are inseparable, but not identical, because the quality of tradition pertains to all the manifestations of a traditional civilization reflecting the spiritual principles of that civilization both directly and indirectly. Sacred, however, especially as used in the case of art, must be reserved for those traditional manifestations which are directly connected with the spiritual principles. Because a tradition embraces all of man's spiritual life and activities in a traditional society it is possible to have an art that has the quality of apparent "worldliness" or "mundaneness" and is yet traditional. But it is not possible to have an example of mundane sacred art. There is, finally, the possibility of a religious art which

[1] The vital spirit.

[2] The soul, the ego, the psyche, the subtle reality of the individual.

is not sacred art, because its forms and meaning of execution are not traditional. It has merely chosen for its subject a religious theme. To this category belong most religious paintings and architecture of the Western world and also some of the popular religious paintings executed in the Eastern world during the past century or two under the influence of European art. Such religious art must be clearly distinguished from real sacred art.

To distinguish between religious and sacred art, which is necessary only in the case of Western art, is relatively easy, whereas to understand the distinction between sacred and traditional art may be more complex. Let us take an extreme example: a genuine medieval sword is a work of traditional art in that it reflects the principles and forms of Islamic or Christian origin. But it is not directly connected with an initiation rite or practice. The Shinto sword in Japan belongs to the category of sacred art because it is a ritual object of high significance in the Shinto religion. Likewise, Persian Quranic calligraphy is sacred art, but the miniature is traditional art reflecting the principles of Islam in a more direct manner.

Logically speaking, sacred art is a branch of traditional art, because they both have the sign of divine wisdom. The divine wisdom breathes spirit through the forms of both sacred and traditional art; hence sacred art is to preserve the divine presence of reality which other-

wise would be overcome by darkness. Sacred art is a gift from heaven which makes accessible to men who live in material forms the light which nourishes their souls, and it makes transparent for them the material forms which are chosen, also by the inspiration of heaven, as its vehicle. As for art, we must remember that the word is derived from the Latin *ars*, which means "to create," but the definition of art is also explained by the 18th century German philosopher, Friedrich Wilhelm Schelling:

> art is the production or result of that conception of things by which the subject becomes its own object, or the object its own subject. Beauty is the perception of the infinite in the finite.
> Art is the uniting of the subjective with the objective, of nature with reason, of the unconscious with the conscious, and there art is the highest means of knowledge. Beauty is the contemplation of things in themselves as they exist in the prototype. It is not the artist who by his knowledge or skill produces the beautiful, but the idea of beauty in him itself produces it.[1]

In my opinion, Schelling's definition of art seems to be traditional. In traditional society, art was dominated by a spiritual consciousness that simplified the features of the sacred image and reduced them to their essential characteristics, but this in no way implies, as is sometimes suggested, a rigidity of artistic expression. In the case of the one who encounters the consciousness of spirituality, his whole life is of art and by this he is able to create and to

[1] In M. Schasler, *Kritische Geschichte der Asthetik*, 1872, I, 13, cited by Leo Tolstoy, *What is Art?* trans. Almyer Maude (Indianapolis: The Bobbs-Merrill Company, Inc., 1960), p. 23.

do things according to the spiritual principle of reality.

This is why the relationship between art and spirituality is extremely profound in all traditional societies--and here the Islamic civilization offers particularly striking examples: the Guilds of Craftsmen and the spiritual and initiatory organizations such as Sufism have been closely linked. To create matter beautifully, to remove its opacity and make it the symbol of a higher level of reality--which is the object of all sacred and, in fact, traditional art--there must be a living intellectual and spiritual tradition which penetrates into the inner meaning of the symbol. The relationship between true art and spirituality is like that of the body and the soul. Without the vital energy of the soul the body would soon decompose and decay, as does art when the light of the spirit no longer breathes within a cosmic climate, thus delivering matter itself from the bond of finitude and making it a mirror for the reflection of the spiritual world.

Art can also be defined as a language of feelings, coordinate with speech, which is the language of thought. The noble function it is uniquely fitted to perform is that of educating the feelings of men. Through art, the thoughts of others, contemporaries or those long dead, are made accessible to men.

The essence of sacred art in Sufism is defined as having four aspects. One of the aspects may be called

imitative art: the tendency and ability to produce, on canvas or in clay, something which one sees. This aspect leads the artist further on the path of art. In order to develop this faculty, the artist's mind must be fully concentrated, otherwise he cannot observe objects and produce the exact beauty of things as he sees them. Concentration has such great power that a concentrated individual can penetrate into an object, and can see it not only from the outside but from the inside as well. In other words, a concentrated person not only sees the form of that object but its spirit.

The second aspect is suggestive art. This can be divided into two categories: first, an art which suggests a certain concept, so that as soon as we see the picture we can explain it, what it represents; and second, expressed in symbols, an art which through a certain symbology expresses a spiritual wisdom. When a person looks at a picture, the more he studies it, the more it reveals the idea, the wisdom, the thought that is hidden in it. Such art is a revelation of spiritual wisdom. The art of Ancient Egypt, of Greece, and especially the art of the Mongolians, and of India, was chiefly symbolic art. In such periods of ancient art, these master artists who were inspired by spiritual wisdom tried to guide humanity through their art. With a hammer and chisel they carved in wood and engraved on the rocks, and left their work in the caves of the mountains and in the old

temples and palaces, an art that expresses spiritual wisdom.

When one visits one of these caves where spiritual wisdom is expressed in the realm of art, one discovers that one symbol can reveal more than a volume of written manuscript. And in this way the sculptures of a temple or a mountain cave were like a library with thousands of books. The one who can read can find divine wisdom there, expressed distinctly and with intelligence and wit.

The third aspect of art is the creative aspect. In this aspect, an artist creates a theme upon which he will work. In this way, the artist creates great wisdom and power; the artist who reaches that stage where he can create can from that moment call himself an artist.

The fourth aspect of art is inspiration. Through inspiration there is a direct expression of the soul. The artist's inspiration may be either human or spiritual grace. High artistic achievement is impossible without at least those forms of spiritual, intellectual, emotional, and physical mortification appropriate to the kind of art which is being practiced. Over and above this course of what may be called professional mortification, some artists have practiced the kind of self-annihilation which is the indispensable precondition of the unitive wisdom of the divine ground.

This fourth aspect may be called giving life to the work of art. In the first three aspects, the work of art is

only art, but in the fourth aspect, the work of art becomes the living reality, and the artist who reaches this stage has reached the highest grade of spiritual wisdom, which is the mastery of art. No artist can reach this stage only by the practice of his art; it is essential for him to know that in order to accomplish great things in the realm of art he needs spiritual wisdom and awareness.

The teachings of mankind such as Plato in <u>The Republic</u>[1] and people such as the primitive Christians, the strict Muslims, and the Buddhists have gone so far as to repudiate all art. But Sufism has not repudiated all art, for art is an indispensable means of communication. Without it, mankind could not exist.

The beauty of art has a tremendous holding power on us. When we perceive a beautiful thing, we don't want to let it go, we never want to stop perceiving it. It is as if our eyes wanted to drown in the sight, our ears in the sound. When a beautiful thing has disappeared, or we have gone our way, we sense a loss, we feel let down. The structure of this feeling is remarkably like post-coital melancholy. It is no wonder that Plato thought of beauty as seductive and described our relation to it as "love." But no less wrong are the people of civilized European society today in favoring any art if it but serves beauty, i.e., gives people

[1] Plato, "Imitative Art: Definition and Criticism (Selections from <u>The Republic, Sophist, Laws</u>)," in <u>Philosophies of Art and Beauty: Selected Readings in Aesthetics from Plato to Heidegger</u>, ed. Albert Hofstadter and Richard Kuhns (Chicago: Chicago University Press, 1964), pp. 8-52.

pleasure. Formerly, people feared lest among the works of art there might chance to be some causing corruption, and they prohibited art altogether. Now they only fear lest they should be deprived of any enjoyment art can afford, and patronize any art. And I think the latter error is much greater than the former and that its consequences are far more disastrous to the society of man.

The Perennial Values in Sacred Art

Unity, in itself eminently "concrete," nevertheless presents itself to the human mind as an abstract idea. This fact, together with certain considerations connected with the spiritual mentality, explains the abstract character of sacred art. Unity, it is true, has a participative aspect, insofar as it is the synthesis of the multiple and the principle of analogy; it is in that aspect that a sacred image presupposes unity and expresses it in its own way; but unity is also the principle of distinction, for it is by its intrinsic unity that every being is essentially distinguished from all others, in such a way that it is unique and can neither be confused nor be replaced.

Much has been written about the formation of sacred art from existing elements of Byzantine, Persian, Hindu, and Mongolian origin, but very little has been said about the nature of the power that wrought all those various elements into a unique synthesis. Nobody will deny the unity of

sacred art, whether in time or in space; it is far too evident. Whether one contemplates the mosque of Cordoba (figure 1) or the great _madrasah_ of Samarkand (figure 2), whether it be the tomb of a saint in the _maghrib_[1] or one in Chinese Turkestan, it is as if one and the same light shone forth from all these works of art.

What then is the nature of this unity? Sufism does not prescribe any particular form of art; it merely restricts the field of their expression, and restrictions are not creative in themselves. On the other hand, it is misleading, to say the least, if one simply attributes this unity to "religious feeling," as one often does. However intense an emotion may be, it will never be able to shape a whole world of forms into a harmony that is at the same time rich and sober, overwhelming and precise. It is not by chance that the unity and regularity of sacred art remind us of the law working in crystals.

There is something that evidently surpasses the mere power of emotion, which is necessarily vague and always fluctuating. We shall call it the "intellectual vision" inherent in sacred art, taking "intellect" in its original meaning as a faculty far more comprehensive than reason or thought, a faculty involving the intuition of timeless realities.

[1] Arabic for "occident." It is traditionally used to denote all the countries lying to the West of the Nile valley, or, in modern terms, the Libyan Republic, the Tunisian Republic, the Algerian Republic, the Kingdom of Morocco, and the Saharan portion of the Islamic Republic of Mauritania.

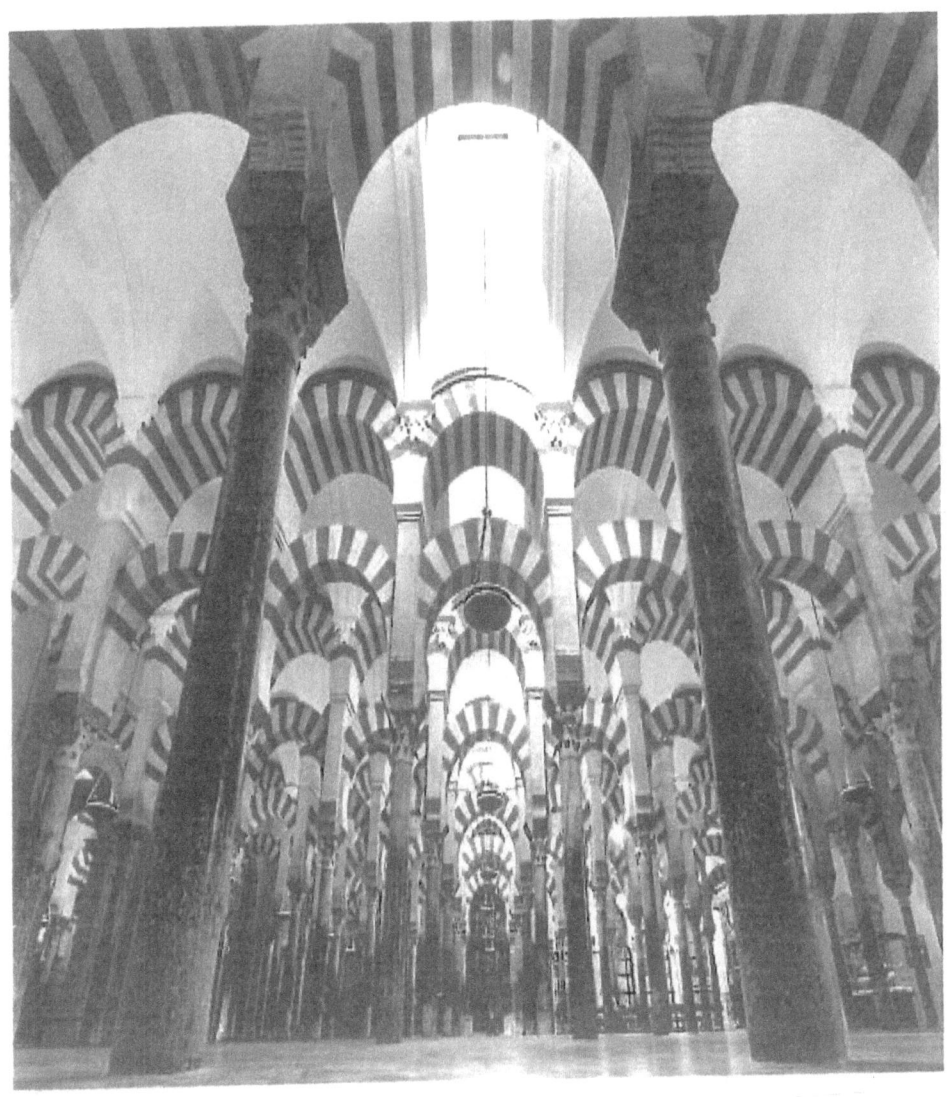

Fig 1. Interior of The Great Mosque of Cordoba.

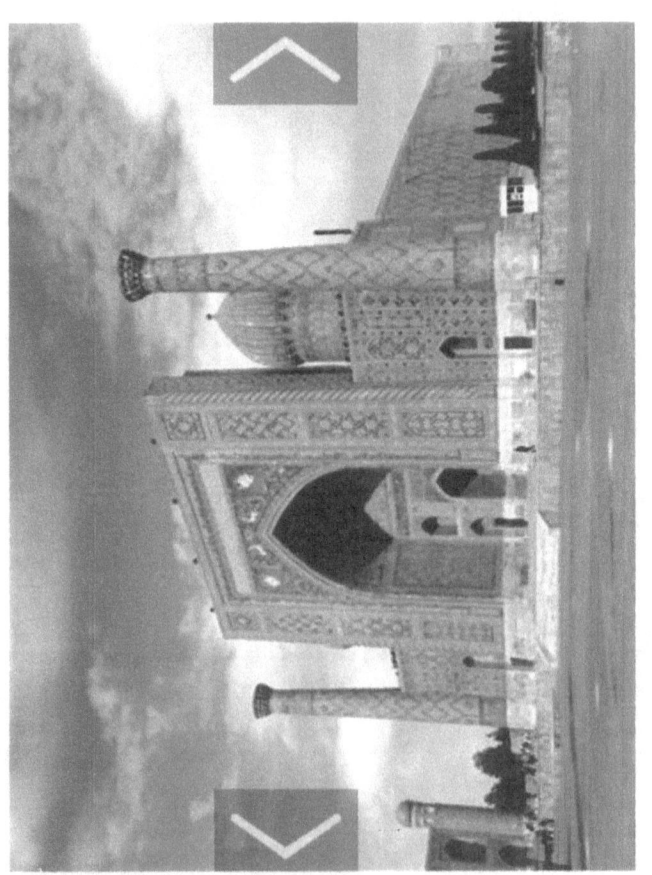

Fig 2. Great Madrasah of Samarkand.

The history of art, being a modern science, inevitably approaches sacred art in the purely analytical way of all modern sciences, by dissection and reduction to historical circumstances. Whatever is timeless in an art--and sacred art like that of Islam or Christianity always contains a timeless element--will be left out by such a method. One may object that all art is composed of forms and, since form is limited, that it is necessarily subject to time; like all historical phenomena, forms rise and develop, necessarily, a historical science.

But this is only one half of the truth: a form, though limited and consequently subject to time, may convey something timeless and in this respect escape historical conditions, not only in its genesis--which partly belongs to infinity to a certain extent at least--for it is with regard to their timeless meaning that certain forms have been preserved in spite of and against all material and psychic revolutions of an epoch; tradition means just that.

On the other hand, the modern history of art has derived most of its aesthetic criteria from classical Greek or from post-medieval art. Whatever its more recent evolution has been, it has always considered the individual as the real creator of art. In this view, work is "artistic" insofar as it shows the stamp of individuality. Now, from a Sufic point of view, beauty is essentially an expression of universal truth.

Thus it is not astonishing that modern science, in studying sacred art, often stops short at a negative judgment. We find such negative judgments in many if not in most learned works on sacred art; they are more or less the same, though different in degree. One often reads that sacred art was creative only at its first stage, while integrating and transforming earlier legacies, and that later on it congealed more and more into sterile formulas. These formulas, we further learn, have not quite canceled the ethnic differences of the people of religious values, but they have unfortunately suffocated the individual initiative of the artist. This happened all the more easily --so it seems--as sacred art was deprived of a most vital and profound dimension through the religious interdiction of images.[1]

We have cited all these judgments in their most acute form, well knowing that few European scholars would subscribe to all of them. Yet it is good to look these judgments in the face, for they will help us by their very limitation to point out the view that reality corresponds to the nature of sacred art. A comparison between the Islamic and the Christian attitudes toward the image of man will aid us to outline things more exactly. In response to the Byzantine iconoclasm, more or less influenced by the Islamic

[1] Titus Burckhardt, "Perennial Values in Islamic Art," in The Sword of Gnosis, ed. Jacob Needleman (Baltimore, Md.: Penguin Books Inc., 1974), pp. 304-306.

examples, the seventh ecumenical council justified the use of icons in liturgy with the following argument: God is indescribable in himself, but since the divine logos assumed human nature, he reintegrated it into its original form and penetrated it with divine beauty.[1]

In representing the human form of Christ, art reminds us of the mystery of incarnation. No doubt there is a sharp distinction between this point of view and that of Islam, but nevertheless both refer to a common basis, namely the theomorphic character of man. Here it is worth mentioning that one of the deepest explanations of the Christian attitude toward sacred art has been given by the famous Sufi, Muhyi-d-din ibn-arabi, ash-shaikh al-akbar, who writes in his <u>Al-futuhat al-Makkiyyah</u>:

> The Byzantine developed the art of painting to perfection, because for them the unique nature (Fardaniyyah) of Sayyidna Isa as expressed in his image is the foremost support of concentration on divine unity.[2]

Sacred art creates a void; in fact, it eliminates all the turmoil and passionate suggestions of the world and builds in their stead an order expressing equilibrium, serenity and peace. From this, one will immediately understand how central the position of architecture is in Islam and in Christianity. Although the prophet said that God favored his community by giving it the whole surface of the

[1] Ibid., pp. 307-308.

[2] Ibid., p. 307. <u>Sayyidna Isa</u> is the Arabic for "Jesus."

earth as a place of prayer, it is architecture that, in populated regions, has to reestablish the conditions of purity and calm elsewhere granted by nature. As for the beauty of virgin nature, which is like the imprint of the creator's hand, it is realized by architecture on another level, nearest to human intelligence and therefore more limited in a way, but nonetheless free from the arbitrary rule of individual passions. Architects of both East and West have endeavored to create a space entirely resting in itself and showing everywhere, in each of its "stations" the plenitude of spatial qualities. They reached this aim by means as different as the horizontal hall with pillars, like the ancient mosque of Medina (figure 3) or the concentric domes of Turkey (figure 4). In none of these interiors do we feel drawn in any particular direction, either forward or upward; nor are we oppressed by their spatial limits. It has rightly been remarked that the architecture of a mosque excludes all tension between heaven and earth.[1]

 A Christian basilica (figure 5) is essentially a way leading from the outside world to the main altar. A Christian dome ascends to heaven or descends to the altar. The whole architecture of a church reminds the believer that the divine presence emanates from the Eucharist on the altar as a light shining in the darkness. The mosque has no liturgical center; its <u>mihrab</u>[2] merely indicates the direction

[1] Ibid., p. 308.

[2] A niche in the wall of a mosque which faces toward Mecca, the holy city of Islam.

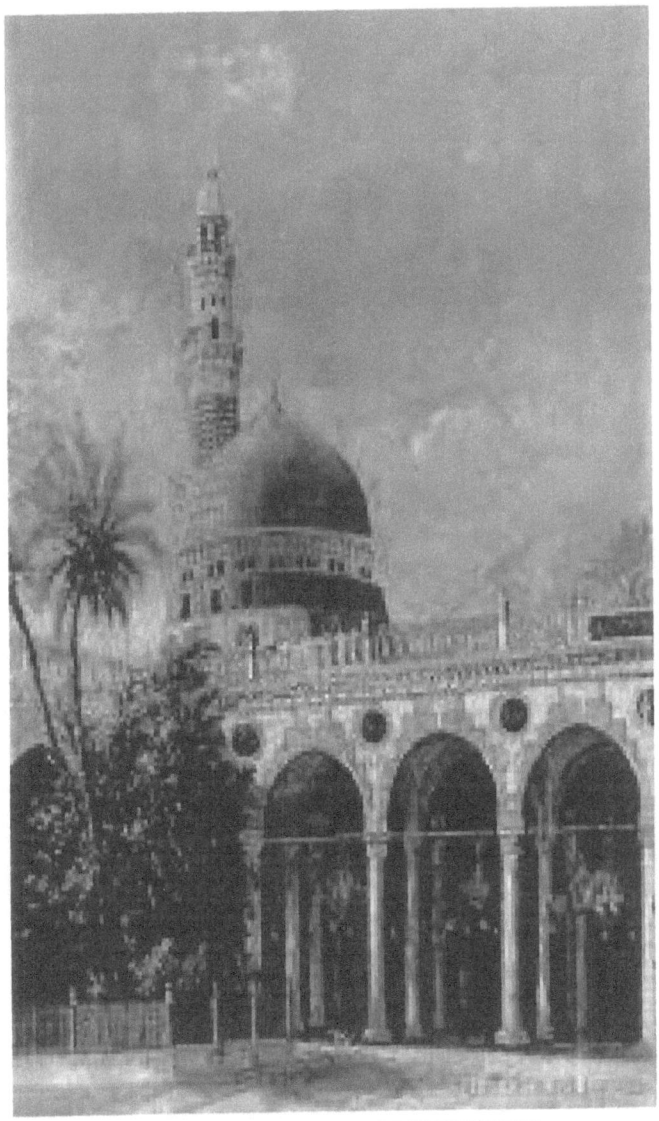

Fig 3. Ancient Mosque of Medina.

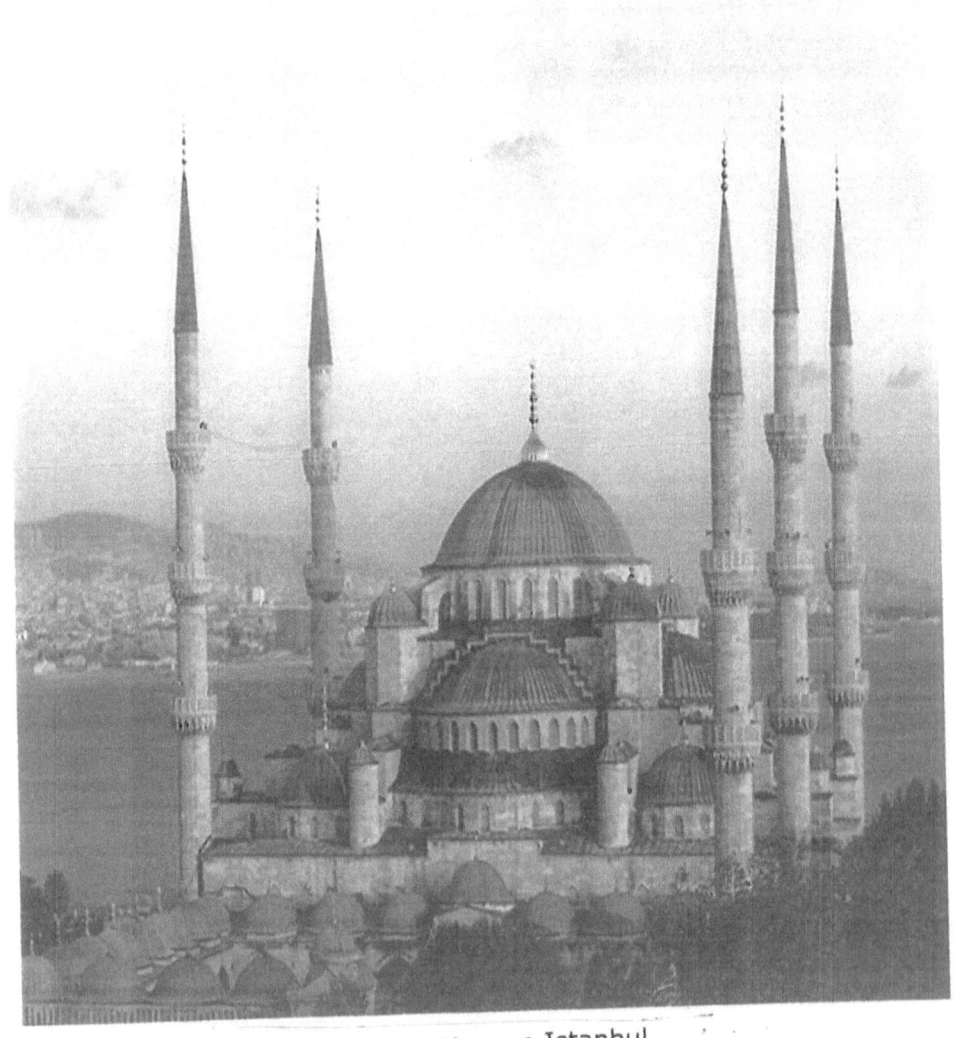

Fig 4. Suleiman Mosque, Istanbul.

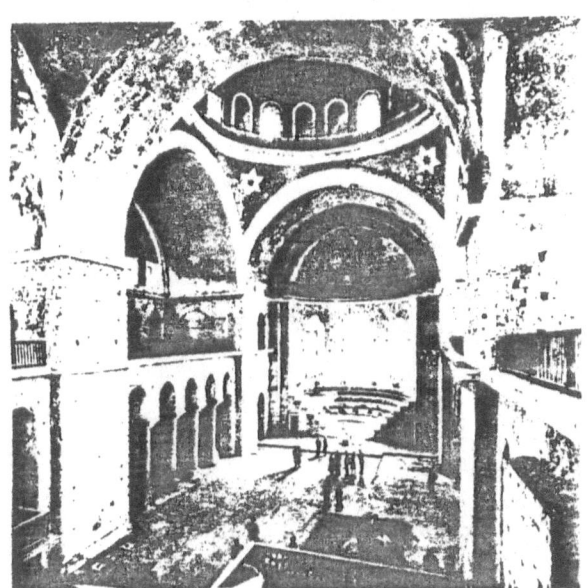

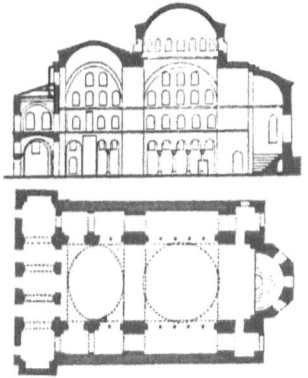

Fig 5. Plan elevation and interior view of the Church of St. Eirene, Istanbul.

of Mecca, while its whole order of space is made to suggest a presence that encompasses the believer on all sides.

Muslim architects spent much attention and love on the form of arcades. No wonder that the Arab name for arcade—— Rawq or Riwaq——is almost synonymous with beautiful, graceful and pure. European art knows mainly two forms of the arch: the Roman arch, which is plain, rational, and static, and the so-called Gothic arch (figure 6)——indirectly derived from Islamic art——with its ascending movement. Islamic art developed a great variety of arch forms, of which two are the most typical: the Persian arch in the shape of a ship's keel, and the Moorish arch (figure 7) in the shape of a horseshoe with a more or less accentuated point. Both arches combine the two qualities mentioned above, namely static calm and lightness. The Persian arch (figure 8) is generous and gracious at the same time; it ascends without effort like the calm flame of an oil lamp protected from the wind. As for the Moorish arch (figure 9), its extreme width is balanced by the rectangular frame: a synthesis of stability and amplitude.

We have seen that the exclusion of images from Islamic art——more severe in Sunnite tha in Shi'ite[1] countries——has a positive meaning, even on the level of sacred art, as it restores to man the dignity that elsewhere is, so to speak, usurped by his image. The immobility with which Islamic

[1] Two different sects in Islam.

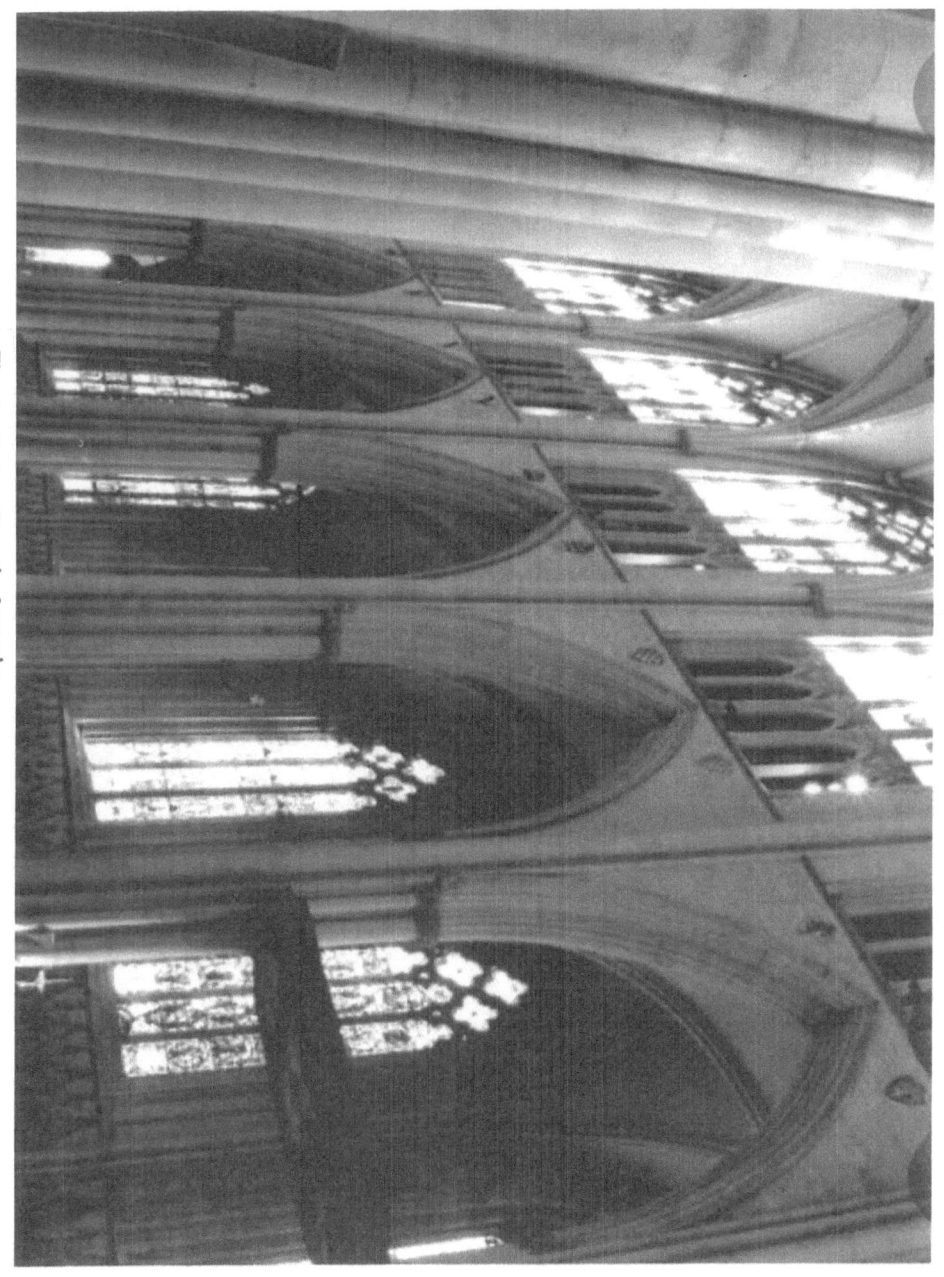

Fig 6. Naive South Arcade, York Minister.

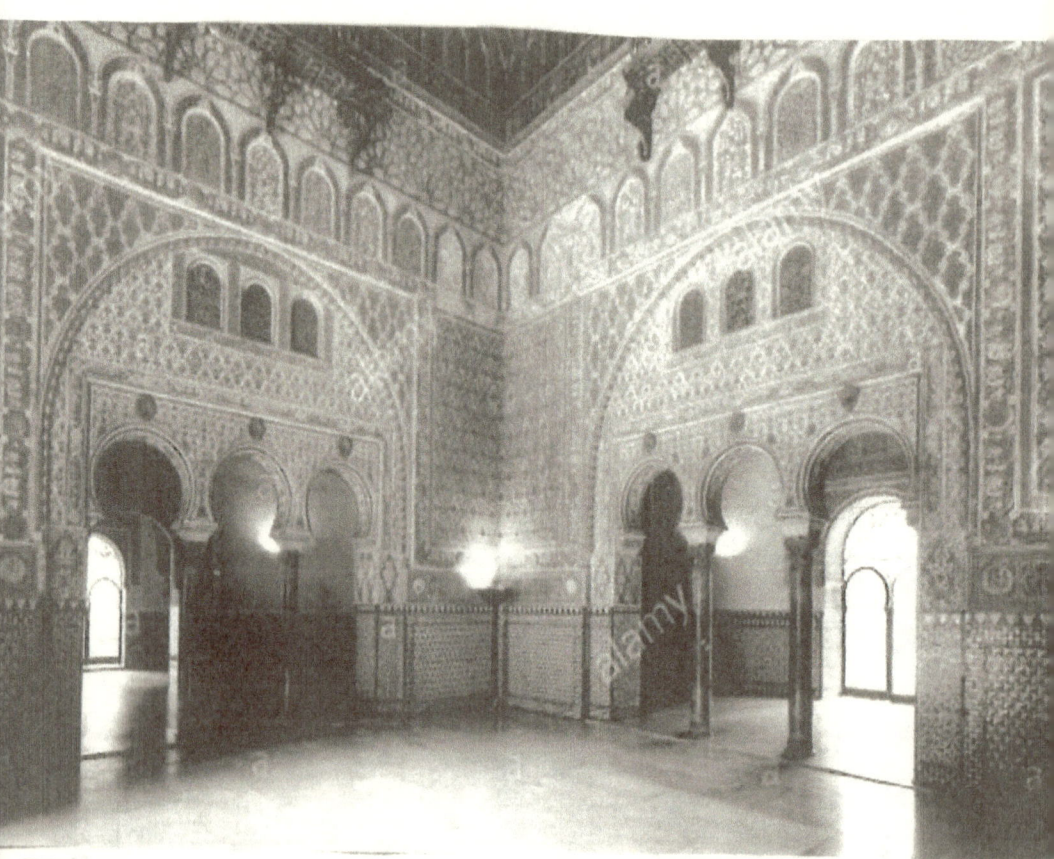

Fig 7. Alcazar-Hall of Ambassadors, Iran

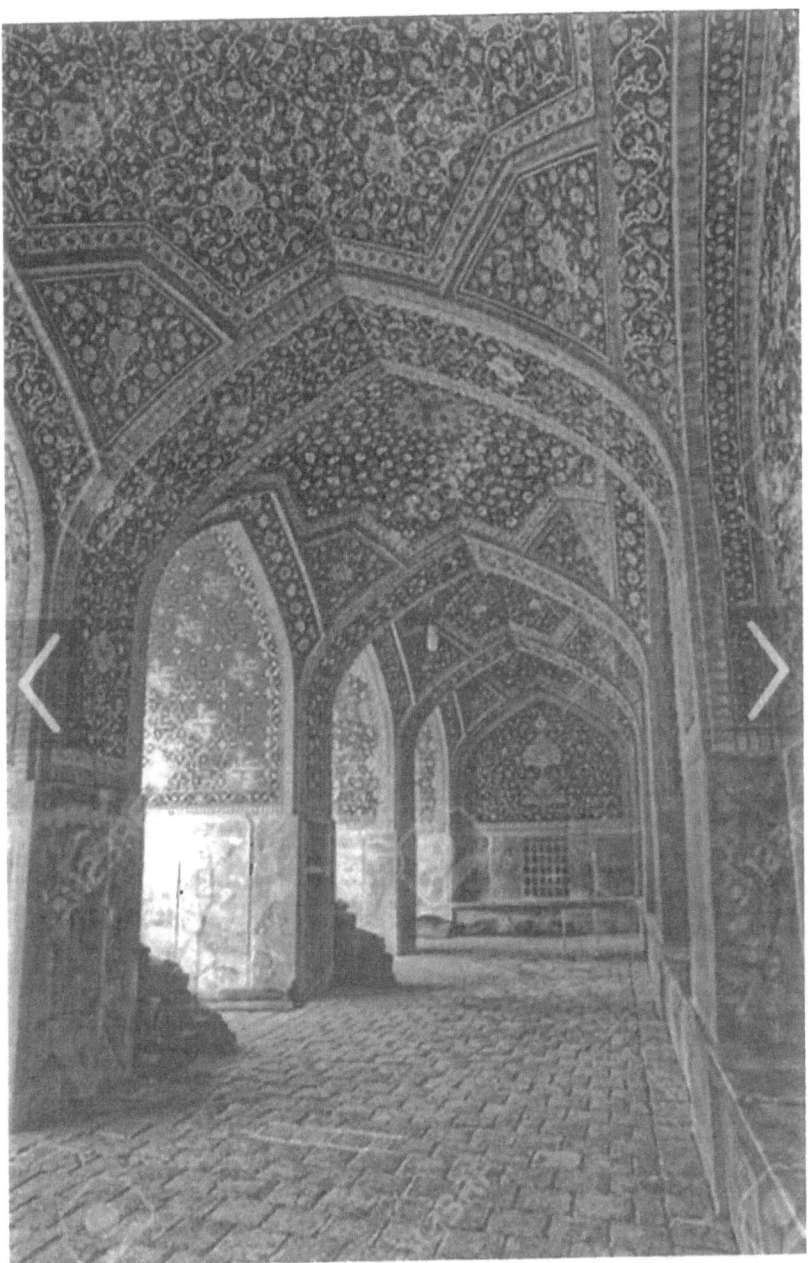

Fig 8. Interior of The Shah Mosque, Isfahan, Iran.

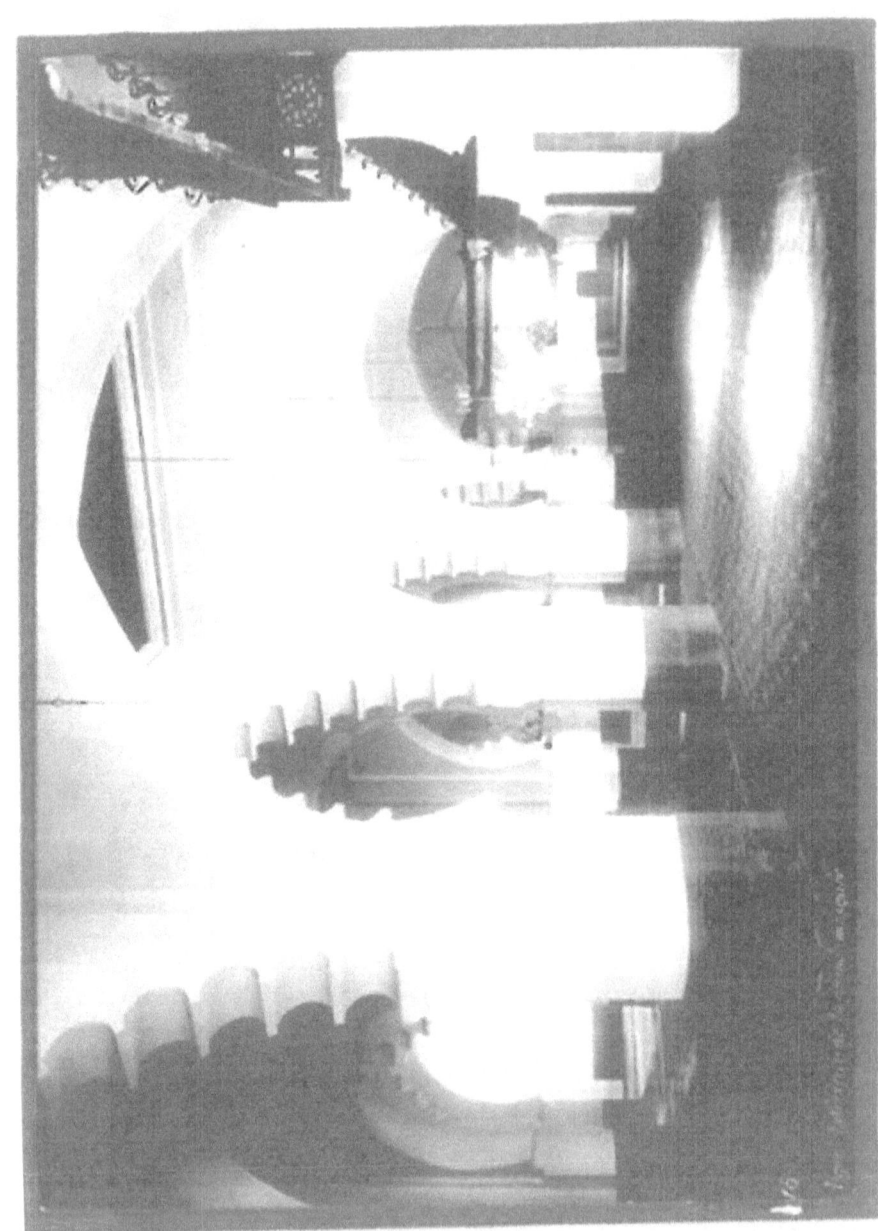

Fig 9. Interior of The Great Mosque in Algiers.

art is reproached is in a certain sense connected with the absence of images, for it is by making images of himself which in turn awaken his reaction and so on, in a chain without end, as we can observe in European art since the purely symbolical role of the image was forgotten. Sacred art is normally protected by its traditional rules from falling into that torrent of change.

However, the use of anthropomorphic images is always fragile, for man is inclined to transfer his own psychic limitations to the image he shapes, in spite of all canonical prescriptions, and then sooner or later he rebels not only against the image but also against what it stands for. Those epidemic outbursts of blasphemy that marked certain epochs of European history are not conceivable without the existence and actual decay of anthropomorphic religious art.

For the contemporary Muslim artist as for all other elements of the classes that mould and give direction to society, the paramount task is one of self-knowledge to cure this abominable inferiority complex vis-a-vis the West, which is based on nothing more than ignorance of the tradition and culture of Persia as well as of the real nature of the modern West. The vastly rich and fecund traditional and sacred art of Islam and of other religions is one of the major means for bringing about a cure for this ignorance and for providing a center and direction for life,

artistic and otherwise. Without it, individual effort will be one more noise added to the clamor and disorder that characterize our times. With it the creative power of the artist as well as the scholar and "thinker" can become like the ray of the sun that dispels the fog, a light that establishes order and elucidates what would otherwise be opaque. It can become like the song of the bird, standing above the sound and clamor that fatigues and sickens the soul of man, to remind man of the peace, tranquility and joy for which he was created and which he seeks at all times knowingly or unknowingly, but which he can only find when he gains an awareness of the sacred and agrees to surrender himself to the will of heaven.

How Does Art Serve the Spiritual Life

Few people today would link art with spirituality, because for most people art is separate from spirituality.[1] But in fact an average person would probably say that "art is what man creates and nature is what God creates."[2] I would prefer to say that nature is what God creates through man. The artist who has approached some perfection in his art will come to realize that it is not he who has achieved in his creativity, it is someone else who has come forward in presenting to him that knowledge of artistic ability.

[1] Khan, The Sufi Message of Hazrat Inayat Khan, Volume X, p. 168.

[2] Ibid., p. 168.

And when an artist produces a work of art, he can do nothing but bow in humility before the unseen power of divine wisdom which takes his body, heart, brain and eyes as an instrument.

Whenever beauty is produced by art, be it music, poetry, painting, sculpture, architecture, writing, or anything else, one may think that man produced it. It is through man that God works his creativity in art, thus nothing is done in this world which is not of divine immanence. It is the separating of the divine work which causes the perplexity that separates man and his art from his Lord. With the linkage of inseparability of art and the spiritual life, one is reminded of the heavenly aspects of life. For example, when the astute observer looks at Michelangelo's Sistine Chapel paintings (figure 10), he notices that these paintings have two planes: one vertical and the other horizontal. The vertical plane corresponds to the creator from whom all things emanate; the horizontal plane corresponds to man, who is the final outcome to which all creation tends.[1]

Art which illustrates the vertical and horizontal

[1] The Christian cross and the Seal of Solomon have significantly the same meaning as Michelangelo's Sistine Chapel paintings. The cross is the symbol of universal man in that the vertical line represents his heavenly exaltation, whereas the horizontal line represents the fullness of human nature. Universal man with his two natures is figured in the Seal of Solomon, of which the upper triangle represents divine nature and the lower triangle represents human nature.

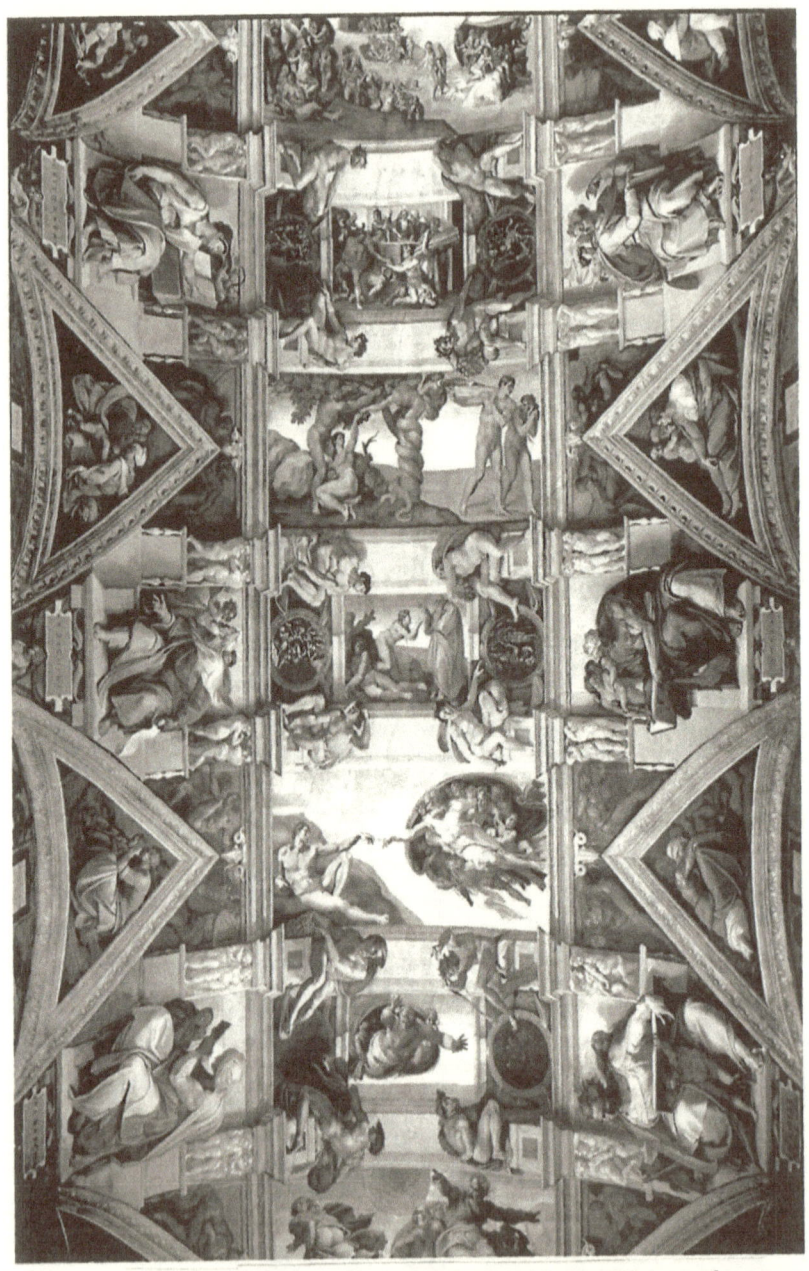

Fig 10. Michelangelo Sistine Chapel Rome.

planes directly enlarges our vision by showing us the vision of spirituality. In this sense it always has some of the essential qualities of Sufism. In a specific manner, it also contributes to the outgoing of the self to reality, by suggesting that the frustration of our desire by things over which we have no control is not final and absolute. Art which includes both planes shows a peculiar sort of responsiveness in matter; its capacity for assuming forms which immediately satisfy our human and spiritual desire provides a presumption, if not a promise, that the unexplored remainder of the spiritual and material may not be wholly alien or incomprehensible to man.

When man is finally able to comprehend and combine the spiritual and material components of matter he will have achieved a spiritual experience approaching the divine wisdom. Consequently, the spiritual development of the artist can be seen in his art, can transfer into his daily life, thereby affecting his relationships with his family, peers, the students he teaches, and mankind. For example, since the Romantic period art has served the purpose of deepening, enriching, instilling, refining, ennobling, and most profoundly, redeeming the spiritual life of man.[1]

[1] Jacques Barzun, The Use and Abuse of Art (Princeton, N.J.: Princeton University Press, 1974), p. 123.

The Way Art Functions in a Person with Spirituality

Art functions as the mechanism through which the spiritually developed individual channels his spirituality, giving it structure and form, so that it may be appreciated by the initiate[1] as well as the enlightened. And spiritual art functions as a revelation and vindication of freedom because it is free from the darkness and incomprehensibility of finite things. Spiritual art interests us, attracts our attention and gives us spiritual pleasure because it corresponds with the rhythm and tone which keep the mechanism of our whole being intact. What pleases us in any art, whether drawing, painting, sculpture, or poetry, is the harmony behind it.

Spiritual art is a bridge that men build to reach each other. And yet it is more than this--more than a mere vehicle of communication. For the function of an art in an individual with any kind of spirituality is only half-truth and in stopping with it we fail to let our understanding reach the fundamental need in the service of which art is merely an instrument. Without consciousness of this need we lose direction, and critical judgment becomes merely a matter of choice between one mode and another. On the other hand, if we can clearly identify the thing we seek, we may find that our historic reliance upon interpretable subject-matter

[1] One whose spirituality is just awakening.

may be the mysterious barrier between the people of modern society and their art. It is certain that we cannot grasp the meaning of the contemporary struggle in art without awareness of the need in us that it strives to satisfy. Without this understanding, all paintings since Cubism must be looked upon as mere visual diversion which fails in its historic purpose because it is not pictorially communicative.

Basically, spiritual art is an expression of the critical need of men to provide their lives with vivid and heart-lifting evidence of the mutuality of their separate existence. The absence of symbols of inner mutuality in contemporary life is not, as in other days, a source of mere disenchantment. The romantic overtones which once surrounded philosophical withdrawal and solitude are gone. The poetic protest becomes a political polemic. Human spirituality has been caught between the tyranny of cold order and resignation to self-destruction, and can only seek survival in new patterns of human mutuality. This search has been going on in painting since the first Cubist and Expressionist experiments at the start of the century. The failure of descriptive painting to reach the heart of contemporary life without a doubt lies in the fact that it has lacked the means and the will to enter this arena.

CHAPTER IV

SUFISM AND ART EDUCATION

Thus far I have explained the concrete elements of Sufism. This chapter will relate those concrete aspects of Sufism to art education in painting and drawing. Education comes from the Latin word *educere*, which means "to draw forth that which is within, to lead." Literally, it means to pack the information in and draw talents out in students.[1] However, contemporary definitions describe art education as providing schooling and developing mentally and morally, especially by instruction. Instruction is defined as giving knowledge. It seems that the contemporary definition of art education is opposed to the root meaning. The practice of art education in modern society appears to be largely equated with the process of instruction, or putting in of knowledge, rather than drawing out.

The practice of art education may seem to be confined to training. However, drawing forth that which is within is a process which cannot be limited to a formal training procedure taking place over a limited span of years. It is a process which takes a lifetime.

In the past, art education was largely mental rather

[1] Joseph T. Shipley, *Dictionary of Word Origins* (Iowa: Ames, 1957), p. 114.

than concerned with the holistic development of a student; it was oriented to the past rather than to the future; it was passive rather than interactive; it was competitive rather than cooperative.[1] The artistic educational experience should focus on the development of self-consciousness in training students in the arts and crafts and making them realize their mission in life.[2] Through art education, a student can communicate his creativity and intellectual capacity to future generations and inspire them with his ideals of life. Art teachers do not seem to know what they should provide for the students and merely attempt to reinforce the status quo.[3] Their art education fails to nurture the development of a positive goal and general outlook in life.

I feel that the student's experience in art education lacks encouragement for self-growth, love, spontaneity, and creativity. The schools do not foster the development of creative attributes or self-reliance; nor do they attempt to open students to a hierarchy of values and a concern with making these operational in life. Within art education there should be acknowledgement, appreciation, and the development of emotional and spiritual aspects in the students, a soul-directed education, which thus far has not

[1] Dionne Marx, "Integral Education," _Integral Education_ 28 (October 1979):12.

[2] Ibid. [3] Ibid.

existed. According to Sri Aurobindo:

> art education begins with the student and the teacher is a facilitator who helps the student to develop from within. The concept here is that students learn by themselves; they grow by themselves. The primary and legitimate role of the teacher is to create an appropriate environment in which the learning process can take place. The role of teachers is not to impose knowledge but rather to guide, suggest, and demonstrate by the example and influence of their own being. Also because each individual is truly unique, the obvious and yet most complete way to encourage the growth process is to let each one follow the bent of his or her own nature.
> Teachers can inhibit development by trying to mold the student in accordance with a preconceived image. Students know and are receptive to what is immediately around them. They are rooted in their heredity, their environment, and their culture, they are sensitive to their past, present, and likely future. Good art education must take all of these factors into consideration; and if it is to meet students' needs and abilities to comprehend, art education must begin with where they are.[1]

Henceforth, Sufism can contribute a great deal in art education, in developing the student's self-consciousness. His art will become a higher realm of spiritual expression. The art of the Middle Ages and the psychology behind it implies that the principal objective of the artist was to produce an object of divine worship. Restricted within the realm of conventionality, having a deeply rooted belief in the sacredness of the artist's task, he considered his art as a spiritual expression of his greatest devotion. And any sensitive individual will certainly feel that the art of the Middle Ages has an atmosphere of spirituality, a feeling of magnetism which grows day after day. No doubt one can only

[1] Cited by Marx, "Integral Education," footnote, pp. 5-6.

appreciate this art if one does not compare it with the art of today; as Majnun said, "to see Leila you must borrow my eyes." So we must borrow the eyes of the people of the Middle Ages, the feeling of the people who lived at that time. They looked at their art as a way of spiritual experience which is a mystery hidden today.

When we think about the Middle Ages and the Renaissance, this wave which came from Ancient Greece to Italy brought new life; yet the art which was once made for spirituality was then made for admiration. Art rose to great heights, bringing the spirit of Classical Antiquity into a new realm of spiritual expression. One can say that the art of the Middle Ages (figures 11 and 12) was directed toward the spiritual world and in the art of the Renaissance spirituality was included; but afterwards it was produced without any kind of spiritual favor. And without spirituality essentially there is no art.

A work of art is distinguished from other products of human skill by the fact that it is to a greater or less extent inspired, and this inspiration confers upon it a value or a significance which otherwise it would lack. Inspiration can be of various kinds and can come from different sources. The difference between a work of art that is ancient in spirit and one that is modern in spirit resides fundamentally in a difference in the nature of its inspiration and in the source from which that inspiration

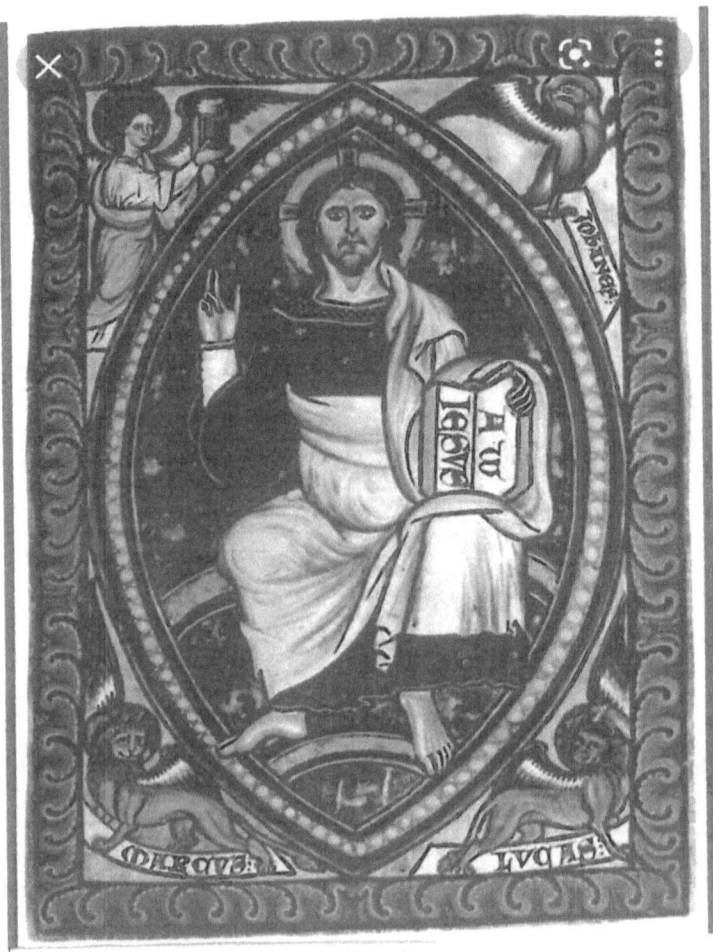

Fig 11. Christ in glory from the Westminister Psalter.

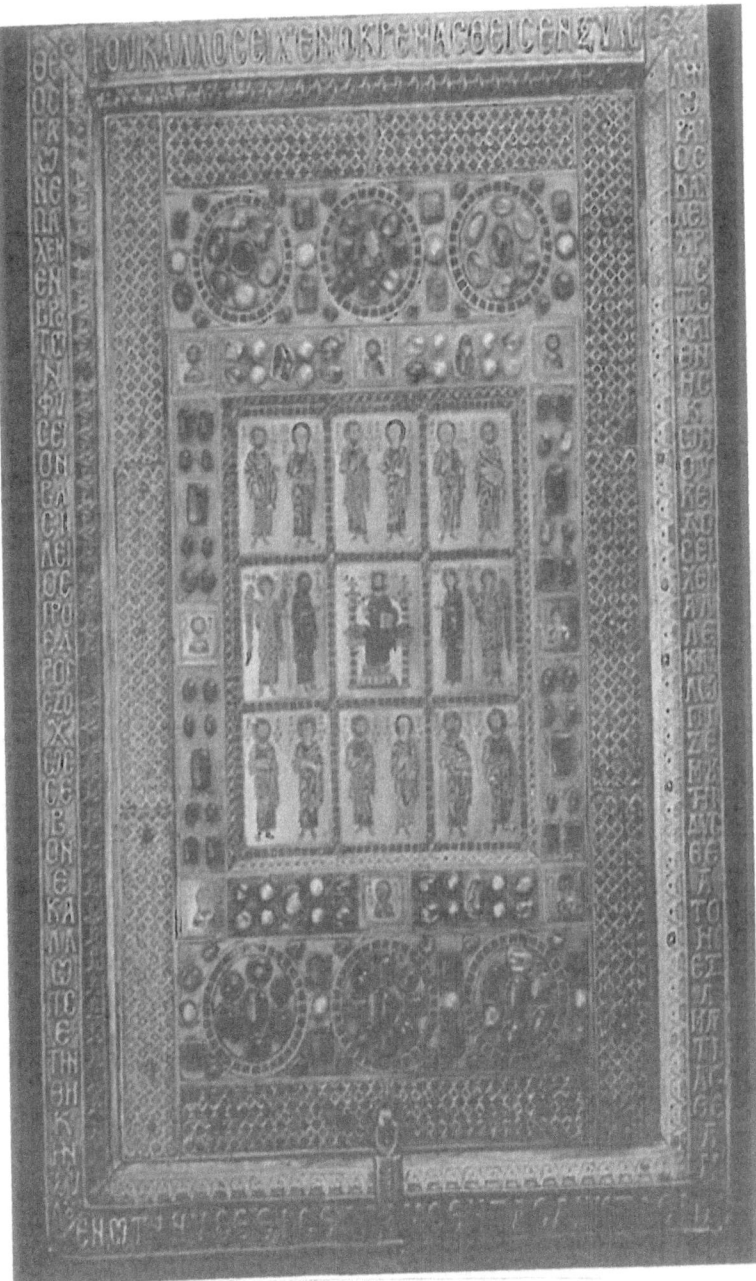

Fig 12. Cover of Reliquary for Preservation of a fragment of the cross.

comes. Neither category can be established by date alone, but art that is ancient in spirit predominates in ancient times, and vice versa; this fact justifies the distinction being made in those terms.[1]

Generally speaking, the distinction can be expressed in the following way: the artist whose work is ancient in spirit, whatever he may take as his model, derives his inspiration from tradition. This is perhaps most evident when the art in question is specifically spiritual in character and intention, and when the artist prepares himself for his work by meditation, music and body movement. In such cases, the artist can be said to seek his inspiration from things of the spirit, which will guide him through his creativity. If his art is not governed by spiritual inspiration, his craftsmanship will lose the very essence of reality.

Painting, drawing, any form of art, is the expression of the soul of the artist. An artist cannot put out what he has not taken in, although mankind ignores the way this is done. The artist's soul conceives, and the artist produces only that which the soul recognizes as having been conceived. Once it is understood that the artist not only produces but also conceives, then it is not difficult for a man whose heart is awakened to see into the soul of an artist. For

[1] Lord Northbourne, *Religion in the Modern World* (London: J. M. Dent and Sons Ltd., 1963), p. 58.

art with color, line, and form is nothing but an echo of his soul. If the soul of the artist is going through torture, his picture gives us the feeling of awe; if the artist is enjoying harmony, we will see harmony in his colors, lines, and forms. What does this show? It shows that the soul works automatically through the brush or tool of the artist. The more deeply the artist is in touch with his inner self, the more spiritually profound his work becomes. When the soul of the artist develops his outward appearance does not necessarily change. However, an inward change occurs and is manifested in specific ways. The first manifestation is the artist's personality. A distinct personality is developed in an artist and expresses itself in everything he does. In other words, an artist's life should be easy, without anxiety and worry, without pressure to produce something. He should be relaxed so that the work of art may come naturally. Then the Creator himself can use the artist as his pen. There is no doubt that suffering can purify an individual and make him more capable of inspiration, but when an artist wants to produce a beautiful work of art, he does not open himself to inspiration by hardening himself, by straining his will, but by opening his heart to the divine essence of spirituality, a dimension of Sufism.

The second manifestation is the creative personality. It is through his inner creativity that an artist can experience a variety of emotions and thoughts that might

otherwise be inaccessible to him. A creative personality brings him joy and a sense of completeness as a person. Through creative achievement, he can give of himself and, in turn, be respected and loved. He has an intensive need to communicate his emotions. The final product becomes an expression of his combined feeling and thinking. Without his particularly strong emotional apparatus, there might well be no creative activity.

In an artistic endeavor, the artist often feels a need to communicate the content of his work without any conscious emotion. He makes a conscious effort to objectify his experience and data. Upon closer observation, one finds that his emotions do propel him to further artistic creativity. Hence, his enthusiasm, rage, aggression, and variety of feelings about his work and the work of others. It is unlikely that any original artistic contribution, no matter how cerebral in nature, has occurred without an emotional determinant, which may simply be the need to advance a new concept in the face of hostility.

To share his experience is the artist's reward. He is gratified when what he has created has reached one individual or many and has enlarged their self-consciousness and, in turn, his own. In this way, both creator and audience feel more alive. It is through mutual or similar responses to the creative achievement that their identity and security becomes reinforced.

The Process of Creativity in Art Education

Sir Herbert Read, one of the most outstanding modern writers on art, says that "creativity should imply the calling into existence of what previously had no form or feature."[1] This means that creativity is the involvement in producing form out of formlessness. In that sense, creativity is applied to the act of divine power, which brought this universe into existence out of nothing. But the possibility of a similar achievement by man is extremely difficult to accept because a state of nothingness or formlessness is unknown to contemporary man. As far as we know, creativity develops through the rearrangement of things that already exist.

Through endowment and developed discipline, creative individuals possess a special faculty. From an accumulation of conscious experiences, they can select, organize, and condense their emotions and thoughts, and synthesize them into new concepts and products.

Theories of the nature of the creative person and process have been linked to medicine since Plato and Aristotle first wrote of the relation between madness and poetry. Plato thought the poet was "indeed, a thing ethereally light-winged and sacred, nor can he compose

[1] Herbert Read, *Education Through Art*, 3rd ed. (New York: Pantheon Books, 1956), p. 113.

anything worth calling poetry until he becomes inspired and, as it were mad,"[1] and Aristotle: "poetry demands a man with a special gift for it or else one with a touch of madness in him."[2]

Throughout the nineteenth century, man's creative process was seen in relation to his social role and his sexual instincts. Darwin, Marx, Nietzsche, and Tolstoy claimed that forces other than man's unconscious life were responsible for his creativity. Tolstoy maintained that art is transmitted feeling which promotes the brotherhood of man and thus has social value. However, it was Darwin's theory of evolution that actually paved the way for the writings of Havelock Ellis and Sigmund Freud, who held the view that man's need to create was closely connected with his sexual energies.

From that time until the present, the dominant theory of the creative person and act stems from Freud's concept of sublimation. Freud hypothesized that the creative act is rooted in transformed sexual energy, in the diversion of these energies to higher, more socially acceptable aims.[3] But creativity or the process of creativity in man is linked

[1] In Plato, *Five Dialogues*, cited by Lawrence Hatterer, *The Artist in Society: Problems and Treatment of the Creative Personality* (New York: Grove Press, Inc., 1965), p. 17.

[2] In S. H. Butcheer, *Aristotle's Theory of Poetry and Fine Art*, cited by Hatterer, *The Artist in Society*, p. 18.

[3] Hatterer, *The Artist in Society*.

to nature, the supernatural, divine revelation, religion, and metaphysical and mystical processes. During most of the Middle Ages, theology prevailed; St. Augustine, among others, saw creativity as divine inspiration.

In his work, an artist is often involved both spiritually and physically. Because of this, dreamlike states can be simulated during the creative act. Such states represent the artist's extreme degree of flexibility in ascending and descending to different levels of consciousness. Needless to say, this is not abnormal; in fact, the artist is more creative when his sensory and spiritual apparatus is highly flexible and able to move back and forth between different levels of consciousness. He has disciplined and organized his feelings and ideas to an unusual degree in order to achieve the proper state of consciousness necessary to produce original work. He is usually not aware of his level of consciousness, but all of his feelings and thoughts are focused on his creative effort. Hence, to ascribe creativity to any single level of consciousness is debatable. To maintain that the artist creates exclusively in a state of reduced or disturbed consciousness, that is, from his unconscious or preconscious, is not an accurate reflection of the extremely organized, disciplined, and at times highly conscious state of the creative mind. Inevitably, all levels of consciousness are involved.

A creative individual looks at things, at the universe

of visible being, intent to grasp in it some reality beyond appearances and some hidden meaning. He receives the spiritual spark (even though charged perhaps with a somewhat sadistic electricity). Then he sets out to express what he has grasped, not by simply transposing the natural appearances of the objects involved, but by using the total difference of other objects belonging in a totally separate sphere--without any flash of intuitive similarity springing forth between these distant objects--so that the secret reality grasped in being will be expressed, enigmatically, through a totally new creation, totally contrived by his own spirit.

Creative intuition and imagination do not proceed in an angelic or demonic manner. They are human, bound to the alertness of sense perception. They grasp a certain transparent reality through the instrumentality of the eye and of certain natural appearances. They cannot express or manifest it except through the instrumentality of these same natural appearances, recreated, recast, transposed of course, not cast aside, and totally replaced by other appearances proper to another realm of things in the world of visible being.

Now, I come to the most important part in this section, the process of creativity in art education. Creativity in art education is a process not only of individuation, but also of integration, which is the reconciliation of indivi-

dual uniqueness with societal unity. From this point of view, the individual will be good in the degree that his individuality is realized with the organic wholeness of mankind. His touch of color contributes, however imperceptibly, to the beauty of the landscape. His note is a necessary, though unnoticed, element in universal harmony.

Creativity in art education fosters individual growth. It is usually regarded as a gradual physical enlargement, maturation, accompanied by a corresponding development of various mental faculties such as thought and understanding. We shall see that this is a wholly inadequate view of what is, in effect, a very complicated adjustment of the subjective feelings and emotions to the objective world, and that the quality of thought and understanding, and all the variations of personality and character, depend to a large extent on the success or precision of this adjustment.[1]

It will be my purpose to show that the most significant function of creativity is concerned with this spiritual orientation, and that for this reason the education of the aesthetic sensibility is of fundamental importance. It is a form of creativity of which only rudimentary traces are found in the educational systems of the past, and which appears only in a most haphazard and arbitrary fashion in the educational practice of the present day. It must be understood from my point of view that what I have in mind is

[1] Read, *Education Through Art*, p. 7.

not merely "art education" as such, which should more
properly be called visual or plastic education; the theory
to be put forward embraces all modes of self-expression,
literary and poetic no less than musical or aural, and
forms an integral approach to reality which should be called
aesthetic education--the education of those senses upon
which consciousness, and ultimately the intelligence and
judgment of the human individual, are based. It is only
insofar as these senses are brought into harmonious and
habitual relationship with both the spiritual and material
world that an integrated personality is built up. Without
such integration, we get not only the psychologically
unbalanced types familiar to the psychiatrist, but what is
even more disastrous from the point of view of the general
good, those arbitrary systems of thought, dogmatic or
rationalistic in origin, which seek, despite the natural
facts, to impose a logical or intellectual pattern on the
world of organic life.

Creativity in art education is the fostering of growth,
but apart from physical maturation, growth is only made
apparent in expression--audible or visible signs and symbols.
Creativity may, therefore, be defined as the cultivation of
modes of expression. It is teaching children and adults how
to make sounds, images, movements, tools and utensils. An
individual who can create good sounds is a good speaker, a
good musician, a good poet. If he can create good images,

he is a good painter or sculptor; if good movements, a good dancer or laborer; if good tools or utensils, a good craftsman. All faculties, of thought, logic, memory, sensibility and intellect, are involved in such processes of creativity. And they are all processes which involve art, for art is nothing but the creativity of sounds, images, etc. The aim of creativity in art education is to instill within the spirit of the artist a greater striving for liberation. In order for the self to be revealed in the work, this greater striving for liberation must be present.

The Sufi Method in Art Education

The first and most obvious affinity between art education and Sufism arises from the fact that art education provides us with a world which is made by human beings for the direct satisfaction of their desires. This is true also of the material apparatus of life; but art education, unlike the things which minister to our physical needs, appeals immediately to personality. The art student puts his whole self into his work, as the engineer or manufacturer does not. The world he presents us with is a more humanized world than that of the man of business or the industrialist. Art education without personality is nothing, but in the sphere of the merely useful, personality is a vanishing fringe around the borders of the mechanical.

Art education, in other words, directly enlarges our

vision by showing us the vision of our fellows, and in this sense it is necessary and always has some of the essential quality of Sufism.

In a less specific manner, also, it contributes to the outgoing of the self into the world, by suggesting that the frustration of our desires by things over which we have no control is not final and absolute. How far the things of the world are really alien and hostile is always a problem. That they may be in a measure controlled materially, science and technology have made clear. But the actual command over "this sorry scheme of things entire" which either individuals or the race can exert, is infinitesimal. Art education, in showing a peculiar sort of responsiveness in matter, its capacity for assuming forms which immediately satisfy our human desires, provides a presumption if not a promise that the unexplored remainder of the world may not be wholly alien or indifferent to us. In this again it joins hands with Sufism.

The value of Sufism through art education is that it will develop the spiritual side of the student. Often spirituality is confused with religion; in reality, however, this word has a quite different meaning. Religion for many is that which they know to be the people's belief; spirituality brings about the divine light which is hidden in every soul. It has no concern with any particular religion. Whatever religion a person belongs to is no good to him if

he has no spirituality.

A student is trained in the spirit of commercialism and, with material motive put before him, can never grow up to become a creative and happy individual who can impart his creativity and happiness to his fellow men. The greatest drawback of so-called modern times is the bringing up of youth in an absolutely material atmosphere, so that they have nothing to look forward to beyond matter and material conditions, which are as poor as matter itself. No student comes to this planet without some kind of a spiritual concept, but it is the environment in which he is raised that makes the child materialistic. It cannot develop by itself when the environment is different. In this way, the spiritual idea which the child brings to earth is strangled by a materialistic environment.

When a student is trained in spiritual concepts, his creative spirit is at work. Not only are body and mind cooperating with instinctive harmony to secure the desired result, but the language of fine arts is functioning at a high degree of excellence. The creative spiritual impulse will keep alive the student's work of art.

The principles of Sufism and art education should be exposed to students, so that they will be helped, without knowing it, to think for themselves so that the process of imaginative creativity will take hold. The freedom of creativity comes in two fashions: one is within onself and

the other is in the environment which one belongs to. To free oneself from within one's very own ego is to "forget oneself." When he reaches this plateau, the artist is more creative in his sensory and mental apparatus, is highly flexible and able to move back and forth between different levels of consciousness. He has disciplined and organized his feelings and ideas to an unusual degree in order to achieve the proper state of consciousness necessary to produce original work.

Hence, to ascribe creativity to any single level of consciousness, the art student must be involved in three Sufi methods that will release his energy so that it can travel throughout the whole body. Once this cosmic energy is released the body takes on the realm of self-awareness, creativity, and expression of cosmic joy.

The first Sufi method is the use of music to help one "get in touch with" one's inner self. This activity promotes the growth of the mind and soul. It allows the "inner self" to experience calmness, contemplation and its own creative imagination. It has fulfilled a variety of functions in both Western and Eastern worlds during the course of its long history. Music, according to the ancients, was not a mechanical science of art, but the first form of communication. The proof of this can be found in the communication of animals and birds, who express their emotions and passions to one another through sounds. It is the combina-

tion of the different sounds of the animals and birds which also has an effect upon the numberless multitudes of the lower creation. If music was the first expressive means in lower creation, so it was in mankind too. And since it was the first expression of the emotions and passions of the heart, it is also the last expression of the emotions and passions; for what art cannot express poetry explains; and what poetry cannot express is expressed by music. Therefore, to a thinker music in all ages will stand supreme as the highest expression of what is deepest in one's inner self.

In some ancient cultures, music was used as a healing mechanism for the soul and body. The concept of healing through music originates with the initial stage of developing through the art of music; this development is the <u>Vedanta</u>, <u>Samadhi</u>, or attainment through music.

In the first place, if we see what is behind all the medicines which are used for healing, if we ask what it is in them that heals, we shall discover that it is the different elements present in these medicines, and that which is lacking in us is taken from them; or the effect which should be produced in our body is produced by them. The musical vibration which is necessary for our health is created in the body by their power; and the rhythm which is necessary for our cure is brought about by bringing the circulation of the blood into a certain rhythm and speed.

Music, like all other forms of art, is of a spiritual

nature. It arises from silence. Its peace and calm manifest the eternal truth in the framework of sounds which belongs to the world of forms and appearances. The quiet and serenity of music is the seal of the world of the spirit impressed upon the countenance of the world of form. The root of every sound takes shape with the depths of this vast universe of silence, a universe that transcends every kind of sound, although all sounds draw their existence from its life-giving force.

Man himself is situated between two worlds of silence, which in a certain respect are ambiguous and unknown for him. The first is the period before birth and the second is after death. Between them, human life is an instant that like a sudden cry shatters the infinite silence for a brief moment, only to become united with it. But this shows that what appears to man as nothingness, that is, the stage beyond the life of this world, is pure being, and what is apparently being--that is, the fleeting instants of life in this material universe--is only the reflection and shadow of the transcendent being. Man's life is also no more than noise and clamor in the face of that eternal silence that in fact is the most profound of all music; and the life of this world comes to possess meaning only when it joins that silence and transforms the noise and uproar of the external world into the enchanting song of the world of man's inner dimension.

For example, Sufis of the Persian and Arabic region from Turkey to Afghanistan are excessively fond of music; and they regard the study of this fascinating art (like dancing) as a worthwhile means of spiritual realization and a path of enlightenment. The relationship of music with Sufism is not accidental, nor is it merely historical. Rather, it is a profound reality that has left a considerable influence upon the way music affects the soul of the listener.

In order for this point to be fully understood, it is necessary to take into consideration the stages of the spiritual path. Although there are various ways of describing and explaining the way toward one's inner self, these can be summarized in three main stages. The first is that of contraction (<u>Qabd</u>). In it, a certain aspect of the human soul must die; this stage is connected with divine justice and majesty (<u>Tajalli</u>). The second stage is expansion (<u>Blast</u>), in which an aspect of the human soul is expanded so that man's existence passes beyond its own limits until it embraces the whole universe, and man can say with Sa'di,

> I am joyful in the world, because the
> world is joyful in him.[1]

[1] S. H. Nasr, "The Influence of Sufism on Traditional Persian Music," in <u>The Sword of Gnosis: Metaphysics, Cosmology, Tradition, Symbolism</u>, ed. Jacob Needleman (Baltimore, Md.: Penguin Books Inc., 1974), p. 335.

This stage is joined to happiness and ecstasy and is the manifestation of the divine beauty and mercy. The third stage is union with reality by means of reaching the stations of exstinction (<u>Fana</u>) and permanence (<u>Baqa</u>). At this level, the Sufi has passed beyond all other states (<u>Ahwal</u>) and stations (<u>Maqamat</u>) and has attained contemplation of the inner self.[1] He sees with manifest clarity that, in the words of Hatif Isfahan,

> He is one and there is naught, but he: There is no God save him alone.[2]

Music is concerned with the second and third states, not with the first.

The Sufis have been completely aware of the importance of listening to music and "spiritual concerts" (<u>Sama</u>) for the development and perfection of the soul, which is none other than the subjugation of animal passions. Ghazzali has written about listening to music and what is permitted and forbidden:

> Know that God, the exalted, possesses a secret in the heart of man which is hidden like fire in iron. Just as the secret of fire becomes manifest and apparent when iron is struck with a stone, so listening to pleasing and harmonious music brings man's essence into movement and causes something to come into being within man without his having a choice in the matter.[3]

[1] Ibid., p. 332.

[2] This verse is the "refrain" of Hatif celebrated in Tarji band, one of the most famous poems in Sufism.

[3] In Ghazzali, <u>Alchemy of Happiness</u>, cited by Nasr, "The Influence of Sufism on Traditional Persian Music," p. 337.

The reason for this is the relationship that exists between the essence of man's heart and the transcendent world, which is called the world of spirits (<u>Arwah</u>). The transcendent world is the world of loveliness and beauty, and the source of loveliness and beauty is harmony (<u>Tanasub</u>). All that is harmonious manifests the beauty of that world, for all loveliness, beauty, and harmony that is observable in this world is the result of the loveliness and beauty of that world.

Therefore, the pleasing and harmonious song has a certain resemblance to the wonder of that world, and hence an awareness appears in the heart, as well as a movement (<u>Barakat</u>) and a desire, and it may be that man himself does not know what it is. Now this is true of a heart that is simple, that is free of the various loves and desires which can affect it. But if it is not free of them, and if it is occupied with something, that thing comes into movement and becomes influenced like a fire which is blown upon. Listening to music (<u>Sama</u>) is important for him whose heart is dominated by the love of spirituality, for the fire is made stronger, but for him in whose heart love is for vanity, listening to music is a deadly poison, and it is forbidden to him.[1]

In conclusion, the appropriate use of music as a teaching technique can inspire the soul of the student

[1]Ibid.

artist. To some extent, the musical technique will attract our attention and give us pleasure in creating, because it corresponds with the rhythm and tone which keep the mechanism of our whole self intact. What pleases us in any of our arts, whether painting, drawing, carving, architecture, or sculpture, is the harmony that lies within the secret or magical beauty of music. In addition, music develops the faculty of appreciating all that is good and beautiful in art.

The wonderful thing about listening to music is that through it one can achieve concentration and meditation independently of thought. In this sense, it bridges the gulf between conscious and unconscious, between form and formlessness. Music will penetrate the student's innermost depths and create an elevating force in his art.

What I am presenting before you now is based on a remarkable experience I had three years ago in a Sufi summer camp near Toronto, Canada, which has continued undiminished until now. This experience shows that there is a divine key, a psychosomatic level in the human brain and nervous system which, by meditation, can lead to self-discipline and to a beatific state of higher consciousness.

In all intellectual and creative work, meditation and absorption have played a most important role. In fact, creative talent is inseparable from absorption. We have heard or read stories about the intense states of absorption

of men of creativity, like Newton and Einstein. During the creative periods of a creative man, an abrupt interruption or disturbance not only is highly disagreeable but also may cause a shock.

Meditation is a natural process and is used for self-realization. If we turn to average men and women, we find here also that it is the moments of intense absorption that provide them with the happiest, most beautiful and most harmonious intervals in their lives. Everyone knows with what concentrated attention one reads a most enthusiastic and fascinating novel. We are absorbed in it heart and soul for a time, and, not infrequently, postpone other work just to have the time to complete it without disturbance and distraction.

When we listen enraptured to music, when we see a masterpiece of painting or sculpture, when we watch a fascinating drama or motion picture, when we see a grand panorama of nature, when we read of the exploits of space travelers and, from their eyes, see the pictures of our earth as a small rotating globe far away, we often enter into deep, absorbed states of mind. It is then that we forget outselves and our surroundings in the intensity of our feelings. The same happens in the play of love. We forget ourselves and the world in the ecstasy of this contact and remain in a state of intense absorption during all the period the contact lasts, forgetting even the flow

of time.[1]

Meditation is also another mode of prayer. There is a certain exterior analogy between meditation and individual prayer in that man formulates his thought spontaneously in both cases. The difference between meditation and individual prayer is that meditation is objective and intellectual, whereas individual prayer is subjective and volitional. In meditation, the aim is knowledge, hence a reality which in principle goes beyond the ego as such. Meditation acts on the one hand on the intelligence, in which it awakens certain consubstantial memories, and on the other on the subconscious imagination which ends by incorporating in itself the truths meditated, resulting in a fundamental and as it were organic process of persuasion.

Meditation proves that one student can do great things even in unfavorable circumstances, provided that he believes himself capable fo accomplishing them, while another, more gifted perhaps, but doubting himself, will do nothing even in favorable conditions. A student walks fearlessly on flat ground, but imagination may prevent him taking a sin le step when he has to pass between two chasms. From this one sees the importance of meditation, even simply from the point of view of auto-suggestion. In the spiritual life, as in other fields, it is a precious help to be deeply persuaded both as

[1] Gopi Krishna, "The Aim of Meditation," in *What Is Meditation?* ed. John White (Garden City: Anchor Books, 1974), pp. 7-13.

to the things towards which we are tending, and also of our capacity to attain them, with the help of our inner selves.

Meditation--as defined in the language of the Vedanta --is essentially "investigation" (Vichara) leading to the assimilation of spiritual truth and then discrimination (Viveka) between the real and the unreal. There are two levels in it, one ontological and dualist, and the other centered on beyond-being or the self, and consequently non-dualist.[1]

Meditation will release the false ego of the student-artist. It will train his latent faculties, bracing and brightening his languid consciousness, emancipating him from the fetters of appearance, turning his attention to new levels of the world. Thus, he may become aware of the universe which the artist is always trying to disclose to the human race. This amount of Sufi perception through meditation is possible to all students of art; without it, they are not wholly conscious, nor wholly alive. The common core of all meditation experience is an altered state of consciousness that leads to a diminishing of ego, the self-centered sense of "I." This core experience state has been called relaxed attention or passive volition. The forms and techniques of meditation have been developed. Some are passive, for example, when a Yogi sits cross-legged in the lotus position with little motion; other forms of meditation

[1] Schuon, Stations of Wisdom, p. 128.

involve graceful body movements such as the whirling dances of Sufi dervishes. Sometimes the ego is open in meditation; sometimes is it closed.

In other traditions, sense organs are emphasized, such as nasal breathing. Sometimes meditative techniques are vocal (of the tongue); some are silent (of the heart). They are generally divided into two branches: recollection with the tongue and recollection in the heart. The latter is usually recognized as superior to the former; spoken meditation, however, plays an important role in the common ritual of the dervishes:

> A man asked Abu Uthman al-Hiri: "I recollect with the tongue, but my heart does not become friends with the recollection." He answered: "Be grateful that one of your limbs obeys and one of your parts is led aright; maybe later your heart too will come into accord."[1]

Even he who offers meditation with his tongue only polishes the mirror of his heart so that it becomes pure. But, as one Sufi has said, it is the mirror itself that should be cleaned, not its handle or its back. If one does not realize the implication of this thought, the danger is that one performs silent meditation "with his stomach, not with the heart."[2]

[1] Schimmel, *Mystical Dimensions of Islam*, p. 171.

[2] Ibid.; Abu Uthman al-Hiri was a companion of the prophet Muhammad.

The types of meditation which will be feasible, for an art class situation are as such: the silent forms of meditation are <u>concentration</u>, <u>contemplation</u>, and mental <u>repetition of a sound</u>. The sound may be a single syllable, such as <u>om</u>,[1] or from classical or rock-folk music. Many Christians used the Lord's prayer as a basis for meditation, and Zen Buddhism has a variety of meditative techniques, some of which involve the use of a <u>Koan</u>, an apparently insoluble riddle that the meditator examines mentally. Thus, while certain meditation techniques emphasize sound, others emphasize mental images using visual forms.

Concentration is generally considered the most complex form of meditation. An image is visualized and steadily fixated in one's mind. The image could be any kind of religious symbol such as the Lotus of the Hindu and Buddhist tradition, or the Crescent Moon of Islam, or Judaism's Seal of Solomon, or the Christian Mystic Rose. Alternatively, the mind may be held free of all imagery and "mental chatter" --clearing away all thought. Or the attention may be focused on the visual image of a painting or a sculpture.

In the more advanced stages of meditation, mental and physical stillness is complete. The meditator is totally absorbed in a blissful state of awareness having no particular object. His consciousness is without any thoughts or other content; he is simply conscious of onsciousness. In

[1] The Tibetan Buddhist <u>om mani padme hum</u> is an example.

Yoga, this emptiness of consciousness without loss of consciousness is Samadhi. In Zen, it is called Satori. In the West, it is best known as cosmic consciousness or enlightenment. And it is paradoxical that in the emptiness comes a fullness--unity with divinity, knowledge of man's true nature, and the peace that passeth understanding.[1]

Meditation is not a thinking process but rather a watching of wonder of your own inner world opening up. And as you are watching, each step suggests to you the next step. Here actually it is not the preceptor (teacher) who is helping you. You will find your preceptor as a light from within yourself. For example, when an artist makes a stroke with his brush, it suggests back to him what is to be the next stroke. He is entering into a dialogue with the canvas. And this dialogue is a two-way progress in which he makes a stroke, and from there a beauty opens up which suggests another beauty. When you go deeper into your mind, it is suggested to you to move in that direction; and that gives to you a greater sense of direction. This, in short, is how the artist enters into the world of meditation. But I do not recommend meditation to anyone unless he shows some kind of tendency to turn inward and to make a search of himself.

Man has composed dances throughout the ages, from the earliest prehistoric era to the present time. In fact,

[1] John White, Introduction to What Is Meditation? (Garden City: Anchor Books, 1974), p. xvii.

dancing and whirling belong to the oldest religious practices of all. Mystical dance was noted by the first European visitors to the convents of the Mevlevis, the whirling dervishes. For the Mevlevis, Tariqa[1] is the only Sufi order in which this whirling movement has been practiced throughout Sufism from early times.[2]

Dance is the "absolute play" and was considered, in Ancient Greece, the movement of the Gods. Both Apollo and Dionysius have dancing movement that suits their particular characters. In primitive societies, dance had a magical character. Rituals to produce rain or ensure victory were usually connected with dance.[3] The Sama (whirling dance)

[1]Dervish (Sufi) order founded by Maulana Jala ad-Din Rumi.

[2]Duncan Black Macdonald, "Emotional Religion in Islam as Affected by Music and Singing;" Fritz Meier, "Der Derwisch Tanz;" and Marijan Mole, "La Dance Exstatique en Islam," all cited by Schimmel, Mystical Dimensions of Islam, p. 179.

[3]Schimmel, Mystical Dimensions of Islam, p. 179.

of the dervishes (<u>Sufi</u>) is an expression of the cosmic joy experienced by the simultaneous effect of annihilation and glorification. <u>Sama</u> is flight within one's self, flutter, struggle desperately like a half-slaughtered bird, blood-stained and covered with dust and dirt.

So dance is the final Sufi method which I would like to see used as a learning technique for teaching painting and drawing. The nature of dance is to go through a journey that will release the cosmic flow of energy. The first condition of this journey is consciousness in regard to the custom of the dance. This dance can be considered as a journey in proceeding to the inner life. Let us imagine this journey we have to make on foot. This at once changes the character of the journey and makes it different from the journeys we are accustomed to. There is no modern equipment, and we must remember that on this journey we have to go through the wilderness, over mountains, to swim rivers in order to get to the other side, to risk all sorts of dangers on the way. That is the kind of journey we have to make in spiritual attainment.

Through dance, the student artist will gain control over his muscles and nervous system, and this has an effect on the mind. A person who lacks control over his nervous and muscular systems has no control over his mind; he eventually loses the very essence of himself. Dance is one of the activities that life draws its power from. With every

creative movement of the body, one draws the life and power of creativity. And when a student artist knows the idea of dance, and draws from the unseen world the energy and power and inspiration, he gets the power to sustain his thought, word, experience, pleasure, and joy.

The ecstasy of dance is the intoxicant that relieves the humdrum existence of tedium, transfigures the ego into its quintessence, pure spirit, and makes the student stir and throb and dance into life, like Shiva[1] dancing the cosmic dance of whirling planets after sitting immobile for aeons on the summit of Mount Kailas. It is pure nostalgia-- man's aspiration to reach beyond himself, not only faced with the immensity of space, or the endlessness of time, or the infinity of numbers, or the limitlessness of possibilities, but the vastness of widening and unending dimensions of understanding and all-encompassing love. It is enhanced by surpassing onself, into a state of penetrating in deep communion, with a feeling of solidarity with the souls of euphoria, then touching upon the secret of existence, and merging the self in the self. Sometimes, the ecstasy of dance can be so intoxicating that one who is carried beyond himself would start whirling. All present would then stand as a sign of respect for the miracle that swept this piece of flesh into what seemed like an accretion of dust caught in a cyclone by sheer wonderment.

[1] A member of the supreme Hindu Trinity.

Therefore, the ecstasy of dance is to tune one's self with the infinity of nature and to stretch one's range of consciousness s widely as possible, so that one may touch the highest form of discovering oneself as a fine order of reality whose frontiers are less defined than the body, or as one's magnetic auric body, as pure thought or feeling, or again as consciousness. And as one awakens, the operation of the impersonal consciousness is not hampered by the vision of the personal focus from affirming its wider vision. One can neutralize the normally confining effect of body consciousness by envisioning one's body and mind through dance.

In art classrooms, the methods using dance as a teaching strategy can be applied with or without music. Not all music is appropriate for dance, and the appropriate areas I have narrowed down to three possibilities: melodic, rhythmic, and dramatic. The melodic, rhythmic, and dramatic aspects of music are those most closely allied to the human body and personality: melody, through its original source in the breath and the voice; metric rhythm, through the enormous range of emotion, always accompanied by a physical and spiritual reaction. In dramatic music, I would include all mood sounds, from the most fully expressed emotional balance to the sparsest, and from elaborate musique concrete to the merest suggestion of tension of the plink-plunk art class.

There is one other way in which music, or, more accurately, sound effects, can be used for dance--for dance can dispense with sound almost entirely and be done in silence. This approach was particularly popular in the twenties and thirties, when many were intent on proving the thesis that dance was an independent art and could stand alone.[1] But these techniques still exist, and have a particular power and fascination of their own. To begin with, dance without music is the absence of sound in a program which is otherwise ear-filling in musical opulence. It has a contrary effect to that which might be expected. It does not seem empty, as though the bottom had dropped out, but increases concentration and attention to movement to an astonishing degree.

[1] Doris Humphrey, *The Art of Making Dances*, ed. Barbara Pollock (New York: Grove Press, Inc., 1959), p. 142.

CONCLUSION

It has often and justly been said that the ills of modern society come from the cleavage between faith and science; paradoxically enough the beginnings of this cleavage are to be found within faith itself, or at least in its extrinsic and subject aspect, in the sense that faith has not been, or is not, adequately buttressed by commentaries of the sapiential order.

In the minds of most people, sentimental rather than metaphysical grounds have been dominant; the intellectual element, thus left neglected outside faith was bound in the end to turn against it. From below and on a purely rational, material level. However, the cleavage in question has yet other causes, subjective as well as objective: on the one hand, the intellectual worldliness ushered in by the Renaissance and by Descartes resulted in a weakening of contemplative intelligence and religious instinct, and on the other hand, new factors - inventions and discoveries of every kind - were to profit from this weakening and have appeared to constitute a glaring contradiction to the tenets of faith. Modern man seems to be less and less capable of intellectual resistance to the suggestiveness of facts which, though belonging to the natural order, lie outside the ordinary, normal experience of human beings.

Thus the tragic impasse reached by the modern mind results from the fact that most men are incapable of grasping the compatibility

between the symbolic expressions of tradition and the material discoveries established by science; these discoveries stimulate modern man to want to understand the 'why' to be as external and as easy as that of 'scientific' phenomena; in other words he wants answers on the level of his own experiences; and since these are purely material, his consciousness is closed in advance to all that goes beyond them.[1]

Never before in the annals of modern society has there been a much greater destruction of life, human values and property. It reminds one of a spider, which weaves its web for its own comfort but cannot get out of the web it has made for itself. And if one goes to the root of this subject one sees that all this destruction has been caused by materialism. Money seems to be the only gain and the only objective. It is undeniable that when one is continually thinking of such, all one's thoughts and energy will go in that direction, and perhaps in the end man awakens and finds that all his life he has given his thoughts to something which does not last, which does not even exist, and which is only an illusion.

In spite of all the progress of modern civilization that has been made in all departments of life, such as commerce, industry, government and economics, the question still remains whether we have really progressed. If one observes the superficiality of the life which man lives today in the so-called civilized parts of the world, one will certainly find that he is far removed from nature both within and without, and he has become an exile from the ideal state of life.

(1) Schuon, Frith Jof, Stations of Wisdom (Translated from the French by G.E.H. Palmer). John Murray, London, 1971, p. 7-9

Look at the central theme of art education of today. Only a short time is given to the child to prepare him for the kingliness of life and the freedom of the spirit. And when the child's intellect grows, every year more and more it sees life before it like an ocean which it has to cross, loke something dark awaiting it. And later when the child has become a man he gives all his time to his work and there is no time even for love or friendship; yet at the end of his life he cannot take all these things with him. After sacrificing all his life to these things, what has he really gained? Through his external life in the world the complications of life have only increased.[2]

What is needed today in the art education system is an introjection of spiritual dimension; sufism can provide this type of spiritual dimension. The first and most obvious affinity between art education and sufism arises from the fact that art education provides us with a world which is made by human beings for the direct satisfaction of their desires.

This is true also of the material apparatus of life; but art education, unlike the things which minister to our physical necessities, appeals immediately to personality. The art student puts his whole self into his work, as the engineer or manufacturer does not. The world he presents us with is a more humanized world than of the man of business or the industrialist. Art education without spiritual personality is nothing, but in the sphere of the merely useful, spiritual personality is a vanishing fringe around the borders of the mechanical.

(2) Barre and Jenkins, the Sufic message of Hazrat Inayat Khan, Volume 10, International Headquarter of the sufi movement, Geneva, 1973, p. 242

Art education, in other words directly enlarges our vision by showing us the vision of our fellows, and in the sense it is necessary and always has some of the essential quality of Sufism. In a less specific manner, art education through Sufism, can contribute to the outgoing of the self into the world, by suggesting that the frustration of our desires by things over which we have no control is not final and absolute.

They may be in a measure controlled materially, science and technology have made clear, but the actual command over this sorry scheme of things entire which either individual or race can exert, is infinitesimal. Art education, in showing a peculiar sort of responsiveness in matter, its capacity for assuming form which immediately satisfy our human desire, provide a presumption if not a promise that the unexplored remainder of the world may not be wholly alien or indifferent to us. In this again it joins hands with Sufism.

Sometimes spirituality is confused with religion; in reality, however, this word has quite a different meaning. Religion is often used to mean simply whatever an individual or a group regards as being true, or that whereby conduct is regulated. Even communism is sometimes loosely called a religion, regardless of its origin and its tendencies, and of the fact that it is no more than a construction of the human mind. In its original and only valid sense the word religion applies only to something which is above all not a construction of the human mind, but is, on the contrary, of divine origin, so that it can be said to be supernatural, revealed or mysterious, and its purpose is

to provide an effective link between the world and God. The word 'Religion' is always used hereafter in its strict sense, and to emphasize this it is spelt with a capital R; whereas spirituality will bring about the divine light which is hidden in every human soul.

When a student-artist is trained in spiritual concepts, his creative spirit is at work, not only are body and mind cooperating with instinctive harmony to secure the desired result, but the language of fine arts are functioning at a high degree of excellence. The creative spirit impulse will to move back and forth between different levels of consciousness.

The aim of a student-artist who is trained in spiritual awareness through the three sufic methods of dance, music and meditation is to contemplate nature and become one with it, to become natural. This is not intended in a pantheistic or naturalistic sense, but in a metaphysical sense, so that to become natural means to abide fully by the Tao which is at once both transcendent and the principle of nature. The aim of the sage is to be in harmony with nature for through this harmony comes harmony with men and this harmony is itself the reflection of harmony with heaven. Chuang Tzu writes: "anyone who sees clearly the excellence of all nature may be called God's Trunk or God's Stock because he is in harmony with nature." Anyone who brings the world into accord is in harmony with his fellow men and happy with men. Whoever is in harmony with nature is happy with nature.(3)

The spiritual awareness will help the student-artist to have the ability to think. This comes about as follows: Perception - that is,

(3) Seyyed H. Nasr, Man and Nature: The spiritual crisis of modern man, (London: Mandala Books, Unwin Paperbacks, 1976), p. 85-86.

consciousness on the part of the person who perceives - is something
peculiar to living beings to the exclusion of all other possible and
existent things. The student-artist may obtain consciousness of things
that are outside their essence through the internal senses that is
given through spirituality. The ability to think is the occupation
with pictures that are beyond sense perception, and the application
of the mind to them for analysis and synthesis.

The ability to think has several degrees. The first degree is
student's intellectual understanding of the things that exist in the
outside world in a natural or arbitrary order, so, that he may try
to arrange them with the help of his own power. This kind of thinking
mostly consists of perceptions. It is the discerning intellect, with
the help of which the student obtains the things that are useful for
him and his livelihood, and repels the things that are harmful to him.

The second degree is the ability to think which provides man with
the ideas and the behaviour needed in dealing with his fellow men and
in leading them. It mostly conveys apperceptions, which are obtained
one by one through experience, until they have become really useful.
This is called experimental intellect.

The third degree is the ability to think which provides the knowledge,
or hypothetical knowledge, of an object beyond sense perception without
any practical activity. This is the speculative intellect. It consists
of both perceptions and apperceptions. They are arranged according
to a special order, following special conditions, and thus provide
some other knowledge of the same kind, that is, either perceptive or

or apperceptive. Then, they are again combined with something else, and again provide some other knowledge.[4]

In conclusion, I feel art education in painting and drawing has become a stagnant pond in which basic teaching methods have been the same over many years. I feel art education needs some new approaches, to attract the interest of new art educators and to stimulate the "niggardly" teaching methods of established art educators. I offer an adaptation of the Sufi meditation, dance and music as a new instrument of art education. From the use of these methods I anticipate development of a continuous flow of new and creative approaches to art education which are long overdue, and to be provided with the perception of existence as it is, with its various genera, differences, reasons and causes. By performing these three Sufi methods, the student achieves perfection in his work and becomes pure intellect and perceptive soul. This is the meaning of human reality.

[4] Ibn Khaldun, The Muqaddimah: An Introduction to history, Translated by Franz Rosenthal (Princeton, N.J. Bollingen series/Princeton University Press, 1974). p. 333-334

Appendix

THE ORTHODOXY OF SUFISM

Sufism is nothing other than Islamic esoterism, which means that it is the central and most powerful current of that tidal wave which constitutes the revelation of Islamic thought. Those who insist that Sufism is free from the shackles of religion do so partly because they imagine that its universality is at stake. But, however sympathetic we may feel towards their preoccupation with this undoubted aspect of Sufism, it must not be forgotten that particularity is perfectly compatible with universality, and in order to perceive this truth in an instant, we have only to consider sacred art, which is both unsurpassably particular and unsurpassably universal.[1]

To take the example nearest our theme, Islamic art is immediately recognizable as such in virtue of distinctness from any other sacred art: nobody will deny the unity of Islamic art, either in time or in space; it is far too evident, whether one contemplates the mosque of Cordoba or the great maghreb of Samarkand; whether it be the tomb of a Sufi saint in the maghreb or one in Chinese Turkestan, it is as if one and the same light shone forth from all these works of art.[2]

Sufism consists of metaphysics, cosmology, psychology,

[1] This emerges with clarity from Titus Burckhardt, Sacred Art in East and West: Its Principles and Methods, trans. Lord Northbourne (Bedfont, U.K.: Perennial Books Ltd., 1967).

[2] Burckhardt, "Perennial Values in Islamic Art."

and *eschatology*, which is often linked up with psychology
and metaphysics. The metaphysical aspect of the doctrine
delineates firstly the nature of reality, the oneness of the
divine essence which alone "is" in the absolute sense and
prior to which there is nothing; then the theophany of the
essence through the divine names of qualities and through
the determination of the different states of being; and
finally the nature of man as the total theophany of the names
and qualities. The doctrine of unity or *tawhid* forms the
axis of all Sufi metaphysics and it is in fact the mis-
understanding of this cardinal doctrine that has caused so
many orientalists to accuse Sufism of pantheism. Sufi
doctrine does not assert that God is the world but that the
world to the degree that it is real cannot be completely
other than God; were it to be so it would become a totally
independent reality, a deity of its own, and would destroy
the absoluteness and the oneness that belong to God alone.

Sufi metaphysics, moreover, delineates the intermediate
levels of existence between the corporeal world and God,
levels of reality which Cartesian dualism removed from the
world view of modern European Philosophy, leaving an
impoverished picture of reality which remains to this day a
formidable obstacle to the integration of contemporary man's
mind.[1]

As for cosmology, Sufi doctrine does not expound

[1] Nasr, *Sufi Essays*, pp. 45-46.

details of physics or chemistry but a total science of the cosmos through which man discovers where he is in the multiple structured cosmic reality and where he should be going. The goal of the spiritual man is to journey through the cosmos and ultimately beyond it. Sufi cosmology provides a plan with the aid of which man can get his bearing for this journey. Sufi cosmology thus does not deal with the quantitative and symbolic aspects. It casts a light upon things so that they become worthy subjects of contemplation, lucid and transparent, losing their habitual opaqueness and darkness.

Sufism was able to integrate many medieval sciences such as Hermeticism into its perspective precisely because these sciences reflect the unicity of nature and the interrelatedness of things; inasmuch as they deal with the symbolic and qualitative nature of objects and phenomena, they accord well with the perspective of Sufism. Moreover, since Sufism is based on experience (the one kind of experience which in fact modern man who boasts so much about his experimental outlook hardly ever attempts to undergo) it has found it possible to cultivate both natural and mathematical sciences in accordance with its own perspective.

As for psychology, it must be remembered that Sufism contains a complete method of curing the illnesses of the soul and in fact succeeds where so many modern psychiatric and psychoanalytic methods, with all their extravagant

claims, fail. That is because only the higher can know the lower; only the spirit can know the psyche and illuminate its dark corners and crevasses. Only he whose soul has become integrated and illuminated has the right and the wherewithal to cure the souls of others.

As for the doctrinal aspect of Sufi psychology, the human soul is there presented as a substance that possesses different faculties and modes of existence, separated yet united by a single axis that traverses all these modes and planes. There is, moreover, a close link between this psychology and cosmology so that man comes to realize the cosmic dimension of his being, not in a quantitative but in a qualitative and symbolic sense.

Sufi eschatology has both a macrocosmic and a microcosmic aspect, the latter being what most immediately and directly concerns the adept. From this point of view, the posthumous becoming of man is no more than a continuation of the journey on this earth to another level of existence, one which, moreover, can already be undertaken here and now by those who, following the advice of the prophet Muhammad, "die before you die," have already died to the life of the carnal soul (al-nafs al-ammarah) and been resurrected in the spiritual world. Sufi eschatological doctrines reveal to man the extension of his being beyond the empirical, earthly self with which most human beings identify themselves. These doctrines are therefore again a means whereby the

wholeness of the human state in all its amplitude and depth is made known, preparing the ground for the actual realization which implies the complete integration of man.[1]

Sufism has succeeded in proving means of integration for metaphysics, cosmology, psychology, and eschatology by wedding its symbols to those of the arts and crafts. Through the process of making things the artisan has been able to achieve spiritual perfection and inner integration thanks to the bond created between the guilds and the Sufi orders. The transformations of color, shape, and other accidents that materials undergo in the hands of the artisan came to possess a symbolic significance connected with the transformation of the human soul. And in this same sphere, alchemy, which is at once a symbolic science of material forms and a symbolic expression of the spiritual and psychological transformations of the soul, became the link between Sufism and the fine arts, and its language the means whereby the maker and the artisan has been given the possibility of integrating his outward and inward life. In this way, as far as the question of the integration of the mind is concerned, the traditional crafts and the methods connected with them came to play a role for the craftsman analogous to Sufism for the contemplative and the thinker.

The Sufis were a group of searching men and women who discovered the realities of human experience by realizing

[1]Ibid., pp. 46-47.

that we are all underdeveloped. One must view oneself in the perspective of evolution and alteration, that is, in order to know one's "true self." Just as we progressively evolved from the inorganic to the animal state, and to our present social state, so too can we further evolve from this state of social being to the cosmic state.

Once awakened, the individual realizes that the same spiritual evolutionary process will develop his mind, and make him realize his need as a spiritual or an intellectual human being. At the next stage he becomes familiar with the idols in his mind and attempts to break them all in order to achieve his new state of life. At this point, the Sufi advances to a level of being as far above the ordinary man as that of man in relation to his earlier existence. The fully-awakened one attains union with all and helps his cosmic self come to light. He becomes a universal man remembering the entire past in the sense of spiritual evolution and seeing the whole of life even in small particles.[1]

Having had an image above all else, motivated by it, he longs for it, becomes concerned with it, and directs his efforts towards attaining it so as to become competitive, but only for himself, for competition with oneself constitutes perfection. However, man's nature does not easily bend toward perfection. While his insight makes him aware

[1] A. Reza Arasteh, Growth to Selfhood: The Sufi Contribution (London: Routledge and Kegan Paul, 1980), p. 134.

of a better life, his human instincts, drives, and selfish
motives may pull him down. Caught up by contradictory
forces in his nature, he immediately becomes anxious. If he
is fortunate, he stands at the threshold of two worlds: his
ego stands up against his real self; the universal man
against the social. In modern times, people generally do
not recognize this disharmony within themselves. When uneasy,
they take a pill, or a drink, or retreat to an illusory way
of life. They achieve tranquillity only as they ignore their
situation. However, if an individual, like the Sufi,
analyzes his situation and becomes critical of it, he cannot
exchange his ultimate certainty for temporary satisfaction.
He becomes even more concerned with his existential problem.

As a searcher for spirituality, he recognizes that he
has only one heart and is potentially one entity; he cannot
split into several parts. The object of this search
consists in the realization of the real self, the state of
universal man. The removal of self means the annihilation
of those experiences which bar the revealing of the real
self. The Sufis call the experience of removal of self as
"I" *fana*, which ends in a state of ecstasy, the feeling of
union and the state of conscious existence.

BIBLIOGRAPHY

Ali Shah, Sirdar Ikbal. *Islamic Sufism*. New York: Samuel Weiser Inc., 1971.

Arasteh, A. Reza. *Growth to Selfhood: The Sufi Contribution*. London: Routledge and Kegan Paul, 1980.

Barzun, Jacques. *The Use and Abuse of Art*. Princeton: Princeton University Press, 1974.

Burckhardt, Titus. "Perennial Values in Islamic Art." In *The Sword of Gnosis: Metaphysics, Cosmology, Tradition, Symbolism*, pp. 304-316. Edited by Jacob Needleman. Baltimore, Md.: Penguin Books Inc., 1974.

_____. *Sacred Art in East and West: Its Principles and Methods*. Translated by Lord Northbourne. Bedfont, U.K.: Perennial Books Ltd., 1967.

Coomaraswamy, Ananda K. *On the Traditional Doctrine of Art*. Ipswich: Golgonooza Press, 1977.

Ed-Din, Abu Bakr Siraj. *The Book of Certainty*. New York: Samuel Weiser, 1974.

Fatemi, Nasrollah S.; Fatemi, Faramarz S.; and Fatemi, Fariborz S. *Sufism: Message of Brotherhood, Harmony, and Hope*. South Brunswick and New York: A. S. Barnes and Company, 1976.

Friedlander, Ira. *The Whirling Dervishes*. New York: Collier Books, 1975.

Hamel, Peter Michael. *Through Music to the Self*. Translated by Peter Lemesurier. Tisbury: Compton Press, 1978.

Hatterer, Lawrence J. *The Artist in Society: Problems and Treatment of the Creative Personality*. New York: Grove Press, Inc., 1965.

Humphrey, Doris. *The Art of Making Dances*. Edited by Barbara Pollack. New York: Grove Press, Inc., 1959.

Huxley, Aldous. *The Perennial Philosophy*. New York: Harper and Row, Publishers, 1970.

Khan, Fazal Inayat. *Old Thinking, New Thinking: The Sufi Prism*. New York: Harper and Row, Publishers, 1979.

Khan, Inayat. *Music*. Geneva: International Headquarters Sufi Movement, 1971.

_____. *The Sufi Message of Hazrat Inayat Khan, Volume VI*. London: Barrie and Jenkins, 1973.

_____. *The Sufi Message of Hazrat Inayat Khan, Volume VIII*. London: Barrie and Jenkins, 1973.

_____. *The Sufi Message of Hazrat Inayat Khan, Volume X*. London: Barrie and Jenkins, 1973.

Kingsland, William. *The Gnosis and Christianity*. Wheaton, Ill.: The Theosophical Publishing House, 1975.

Krishna, Gopi. "The Aim of Meditation." In *What Is Meditation?* pp. 7-13. Edited by John White. Garden City: Anchor Books, 1974.

Lings, Martin. *A Sufi Saint of the Twentieth Century, Shaikh Ahman al-'Alawi: His Spiritual Heritage and Legacy*. 2nd ed. Berkeley and Los Angeles: University of California Press, 1973.

_____. *What Is Sufism?* Berkeley and Los Angeles: University of California Press, 1977.

Marx, Dionne. "Integral Education." *Yoga Journal* 28 (October 1979):12.

Nasr, S. "The Influence of Sufism on Traditional Persian Music." In *The Sword of Gnosis: Metaphysics, Cosmology, Tradition, Symbolism*, pp. 330-342. Edited by Jacob Needleman. Baltimore, Md.: Penguin Books Inc. 1974.

_____. *Sacred Art in Persian Culture*. Ipswich: Golgonooza Press, 1971.

_____. *Sufi Essays*. New York: Schocken Books, 1977.

Needleman, Jacob, ed. *The Sword of Gnosis: Metaphysics, Cosmology, Tradition, Symbolism*. Baltimore, Md.: Penguin Books Inc., 1974.

Northbourne, Lord. *Religion in the Modern World*. London: J. M. Dent and Sons Ltd., 1963.

Plato. "Artistic Inspiration (Selections from Ion, Phaedrus)." In *Philosophies of Art and Beauty: Selected Readings in Aesthetics from Plato to Heidegger*, pp. 53-67. Edited by Albert Hofstadter and Richard Kuhns. Chicago: University of Chicago Press, 1964.

 _____. "Imitative Art: Definition and Criticism (Selections from *The Republic, Sophist, Laws*)." In *Philosophies of Art and Beauty: Selected Readings in Aesthetics from Plato to Heidegger*, pp. 8-52. Edited by Albert Hofstadter and Richard Kuhns. Chicago: University of Chicago Press, 1964.

Read, Herbert. *Education Through Art*. 3rd ed. New York: Pantheon Books, 1956.

Scharfstein, Ben-Ami. *Mystical Experience*. Baltimore, Md.: Penguin Books Inc., 1974.

Schimmel, Annemarie. *Mystical Dimensions of Islam*. Chapel Hill: The University of North Carolina Press, 1975.

Schuon, Frithjof. "The Degrees of Art." *Studies in Comparative Religion* 10 (Autumn 1976):194-207.

 _____. *Dimensions of Islam*. Translated by P. N. Townsend. London: George Allen and Unwin Ltd., 1969.

 _____. *Stations of Wisdom*. Translated by G. E. H. Palmer. London: John Murray, 1961.

 _____. *The Transcendent Unity of Religions*. Translated by Peter Townsend. New York: Harper and Row, Publishers, 1975.

Tolstoy, Leo N. *What Is Art?* Translated by Almyer Maude. Indianapolis: The Bobbs-Merrill Company, Inc., 1960.

Underhill, Evelyn. *Practical Mysticism*. New York: E. P. Dutton, 1915.

White, John, ed. *What Is Meditation?* Garden City: Anchor Books, 1974.

Wolff, Robert Jay. *Essays on Art and Learning*. New York: Grossman Publishers, 1971.

www.ingramcontent.com/pod-product-compliance
Lightning Source LLC
Chambersburg PA
CBHW030841180526
45163CB00004B/1419